MY PHOTOGRAPH

24 IDEAS ABOUT PICTURES

PAUL ZELEVANSKY

GREAT BLANKNESS PRESS

2008

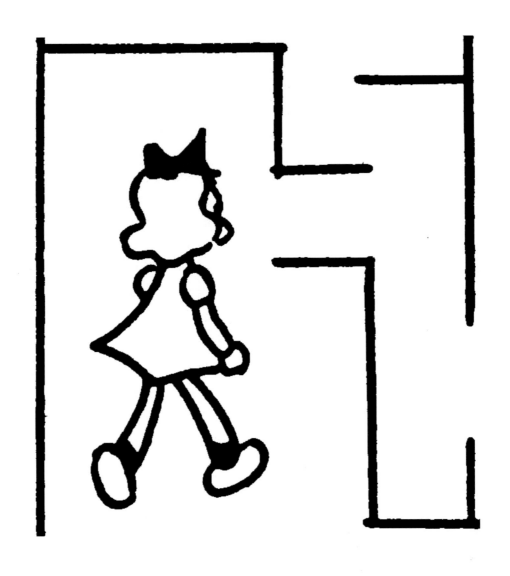

24 IDEAS ABOUT PICTURES

ISBN: 978-0-6151-9886-6
PUBLISHED BY GREAT BLANKNESS PRESS
www.greatblankness.com

24 IDEAS ABOUT PICTURES

1. A PICTURE IS IN FACT A LESSON
2. PICTURES HAVE CHARACTER
3. PICTURES LOOK YOU IN THE EYE
4. PICTURES MEASURE AND REFLECT
5. PICTURES STAND BETWEEN
6. PICTURES ARE SELF-SERVING
7. PICTURES ADOPT A POINT OF VIEW
8. PICTURES RELY ON AN INVENTORY OF EFFECTS
9. PICTURES HAVE NO EFFECTS, ONLY ATTITUDES
10. "A PICTURE IS A MODEL OF REALITY"
11. PICTURES ARE SENTIMENTAL
12. PICTURES ATTRACT AND REPEL
13. PICTURES GIVE DIRECTION
14. PICTURES ELIMINATE DOUBT
15. PICTURES MASK DOUBT
16. PICTURES ARE LIKE AN OVERHEARD CONVERSATION
17. PICTURES ARE BLANK SLATES
18. PICTURES ARE ASLEEP UNTIL THEY ARE AWAKE
19. PICTURES SAVE TIME AND MONEY
20. PICTURES ARE SCAPEGOATS
21. PICTURES ARE ABSTRACT
22. PICTURES NEED YOUR ATTENTION
23. PICTURES SEAL THEIR OWN FATE
24. A PICTURE IS IN FACT A FILE

INTRODUCTION

2.12 A picture is a model of reality. (L. Wittgenstein, *The Tractatus*, 8)

Identification rests upon organization into entities and kinds. The response to the question "Same or not the same?" must always be "Same what?" Different soandsos may be the same such-and-such: what we point to or indicate, verbally or otherwise, may be different events but the same object, different towns but the same state, different members but the same club or different clubs but the same members, different innings but the same ball game... (Nelson Goodman, *Ways of Worldmaking*, 8)

In theory, there is no difference between theory and practice.
In practice there is. (attributed to Yogi Berra)

POWERFUL AND UNRELIABLE:

24 IDEAS ABOUT PICTURES is made up of 24 visual/verbal propositions about the **grammar**, **meaning**, and **metaphysics** of pictures. Utilizing a step-by-step structure in which each lesson builds on those that precede it, 24 IDEAS considers what makes pictures--in collusion and competition with words--alternatively powerful and unreliable as representations of reality.

When Wittgenstein says that **"A picture is a model of reality,"** he is referring to its **grammar**: the quality and composition of its constituent parts. This does not mean that a picture is an ideal from which all understandings of a particular reality flow (although it can be used to represent that). What it does mean is that the way a picture is constructed--the formal arrangement of its elements, the common associations assigned to its content and form--is a depiction of reality in the same sense that a sentence made of words is.

Like a text, a picture is the product of a conventional language, incorporating accepted meanings and prescribed uses. Made up of lines, shapes, colors, tones, and iconography, pictures can be read in terms of the formal compositional choices made by those who produce them, but also understood in their relationship to other pictures. In this way, the expectations of visual interpretation and belief are woven into the process of looking and associating: part to part, example to example.

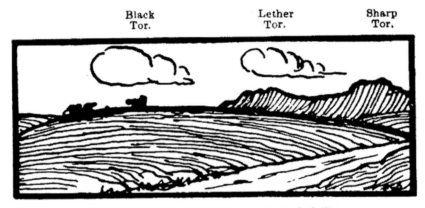

Black
Tor.

Lether
Tor.

Sharp
Tor.

FROM DOUBLE WATERS, LOOKING S.W.

2.14 What constitutes a picture is that its elements are re-
lated to one another in a determinate way. (Wittgenstein, 9)

This illustration from *A Pocket Guide to the Hills and Tors of Dartmoor* by P.G. Stevens portrays a generic rural landscape. Drawn with pen and ink, it is conceptually reliant on our experience of the horizon line between earth and sky (the density of land, the weightlessness of clouds) but the captions tell us that we are looking at a specific array of hills from a particular direction. While not an abstract map that measures distance and scale, the captions provide a functional key to position and location. Despite its lack of fine detail, the drawing carries some sense of place, immediacy, and authenticity because it appears to be done on site.

Wittgenstein's proposition 2.14 refers to the determined arrangement of elements that constitute a picture (or a statement that presents the idea of a picture). We can claim that a picture is worth a thousand words because the picture and the words it evokes are--like a text and its translation--locked in a mutual embrace. One can't be understood apart from the other. Therefore, whether in support of beauty or fact, there is no essential truth to depiction, only the coherent alignment of words and pictures to the conventions of vision and interpretation.

Pictures represent specific goals and communication strategies that unfold in particular contexts. This is one of the implications of Nelson Goodman's statement about "entities and kinds." Once you identify the details of a picture, idea, or thing, distinctions about categories and comparisons with other things become paramount. That is, the meaning of a picture is a product of what it appears to be, what it is not, and finally what the artist or designer wants you to believe it is. In 24 IDEAS, most of the illustrations used are borrowed from resources not produced by the author, so the question of whose meaning is in play is always present.

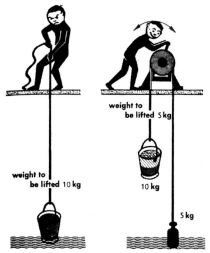

Fig. 1 PRINCIPLE OF WEIGHT AND COUNTERWEIGHT

(*THE WAY THINGS WORK*, 239)

This diagram from *The Way Things Work* was designed to visualize principles of physics, not the weight and counter-weight of contingent arguments, but that is what it has been hijacked to do here. While a counter-argument may weaken or deny a point of view, it also takes some of the weight off the original assertion. On the other hand, we could see a counter-argument as a new perspective, a better example, or a variation on a theme that can deepen an understanding of "entities and kinds." In regard to 24 IDEAS, such distinctions require a picture to carry a heavy load, and credit should be given to the little man performing his task for the benefit of other pictures.

Sometimes, in order to serve new goals, a picture has to fall from one intellectual height to rise up to another. This is the way things work.

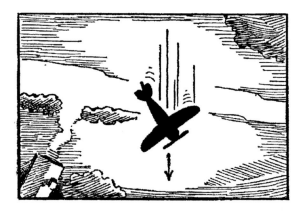

(Assen Jordanoff, *FLYING and HOW TO DO IT!*)

In 24 IDEAS, underlying all speculations about the reading and effects of pictures is a concern with the frames and conventions of **presentation.** When a picture is offered as an example of or commentary on reality, it takes its stand in a particular medium or form. It is a portrait, a sketch, a diagram, a cartoon, and so on. This list does not begin to describe the type and style of portrait or sketch, no less the circumstances in which it is framed and justified. Therefore, in theory and practice, the conventions that set the terms of the exchange wrap a presentation like a gift, which, even if it is welcome and expected, puts the recipient in a compromised position.

24 IDEAS is a book, and you could say that a book is both a gift and a highly respected model of reality. The authority of the book is a product of its long history as a communicative form, but what sustains this is the correspondence between its established conventions—page turning, numbered pagination, running heads, chapters, galleys of type, footnotes, endnotes, and indexes--and the strategies used in making its particular case. With 24 IDEAS, there will be a self-reflexive effort to cast light on how this book's terms are arrayed: that is, how does 24 IDEAS present itself?

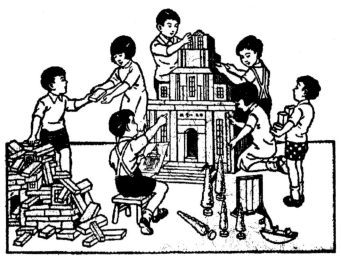

For example, this illustration from a Taiwanese school primer is emblematic of childhood cooperation, industriousness, and commitment to a group goal: block building as a form of nascent play architecture that can be used to reach heights, contain space, create order, or enact destruction and renewal. Here the image represents an ideal for the book as a whole: block building as a metaphor for the studied creation of a *constructive*, yet necessarily fragile balancing of example and argument.

In 24 IDEAS, the cast of visual players is not only used to support assertions and characterizations, but to endorse an undercurrent of speculation and constructive doubt. Think of the circumstances of the playing card: two sides which alternately reveal and conceal in the service of many different agendas invested in an unlimited number of games. Further, while 24 IDEAS reads like a book, its graphic forms--both captioned and left to drift without attribution-- colonize and traverse space like an artwork. Each graphic intervention has the additional effect of transforming the flat neutrality of the page into a potentially malleable geographical space: a narrative and visual ploy made possible by coercing the codex book to play straight man to pictorial illusion.

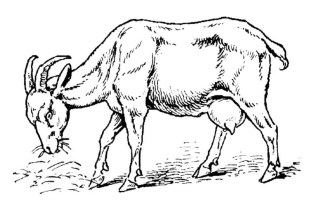

Throughout the book, characters like the smiley face, the billboard man, the spelunker in the cave and the footprint, function as graphic metaphors that reify ideas on the page. For example, the clip-art goat grazing above (and apparently behind) this paragraph will later serve to represent the Old Testament scapegoat, but is here proposed as a four-legged stand-in for the author engaged in satisfying and nutritious self-reflection: grazing in the fertile fields of knowledge and visual culture. It is also a reminder that reading is a digestive process. The goat is a ruminant with a compound stomach that requires several stages to process what it takes in. In this book, contemplative rumination is certainly favored over mindless consumption and elimination.

The goat is also used here to form a bridge to the issue of **metaphysics**:

That is, after considering the goat's role in the text--how it yields both pragmatic and symbolic meaning--we might ask more broadly why we would trust pictures to stand in for us, to characterize our personal beliefs, hopes, and fears, no less to explain and justify the terms of cosmic order and significance.

Like the goat, the iconic and symbolic heart also carries metaphysical inclinations. Whether indexing categories of generic love

or transcendental communication--as in Psalm 19: "Let the words of my mouth and the meditation of my heart be acceptable in Your sight, O Lord, my strength and my Redeemer"--the heart represents the desire to make feelings manifest and transmittable in the world. The heart wants to be seen and heard, as well as felt. Trust me.

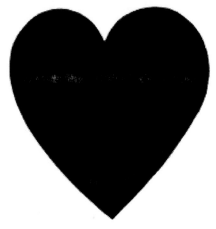

"WHEN YOU GET TO THE FORK, TAKE IT."

Metaphysical as well are the various zen-like statements attributed to New York Yankees' catcher Yogi Berra. His splitting the difference on the relationship between theory and practice is echoed in another assertion of studied ambivalence: "When you get to the fork, take it." While this was apparently a set of directions to Berra's New Jersey home, which could be approached from either leg of the fork in a road, it is also a model for investigating the varied contingencies that define pictures. Berra's acceptance of the often flexible boundaries of perception and language are also indelibly reliant on commonplace experience and usage. His authority is a product of respect for his mastery of baseball and the plain-spoken tone that makes him a modest and trustworthy philosopher without portfolio.

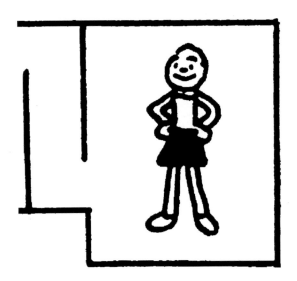

Over the course of 24 IDEAS, selected images and symbols are repeated: sometimes taken through simple permutations, at other times asked to call out to each other from distant locations in the text. Dickie, the figure pictured here, is poised to begin his own journey. An alert but wary refugee from a 1950s pencil and paper maze, he bears the spirit and style of his puzzle-book roots, but is required to straddle more than one conceptual dimension. Whether lost in a section of a maze, awaiting the author's instructions, or just taking a breather, Dickie is a cartoon character caught in a state of anticipation, subject to forces beyond his control.

8

Digitally scanned and sampled from a game pamphlet, he owes the apparent stability of his position on this page to an invisible formatted frame provided by the word processing program. With a half smile--is it wistfulness or veiled terror?--he looks out from this graphic sanctuary, but as a boy and as an illustration his position is transient.
Dickie is *in* transition.

THINKING ABOUT SOMETHING:

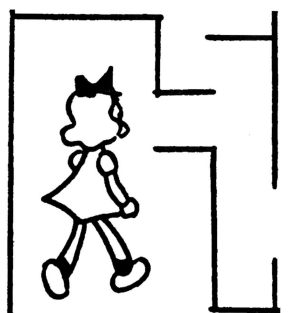

Doris, Dickie's compatriot in the maze, is presented here in the act of crossing through another of its compartments. Provoking uncertainty by turning her back on the reader, she could be entering or leaving or exploring the maze in no particular hurry. Since her face is hidden her intentions are unknowable. In the full maze (on view later on) she and Dickie serve as proxies for the reader's efforts to solve the puzzle, but for now she is just another designated actor in motion and the maze section is her fork in the road. This picture is a model of a fictional reality.

Meanwhile, nearby on a beach, sit a guy and a girl: Two images thinking about something--maybe each other.

Their proximity in the book to Doris and her section of maze doesn't put them inside the puzzle, but could suggest an alternative destination for Doris: The distinct weight and character of the lines that make up her form would not be an insurmountable obstacle if she had an appropriate bathing suit to put on. In any event, the guy and the girl on the beach look, like Doris, both defended and revealed. The guy clasps his

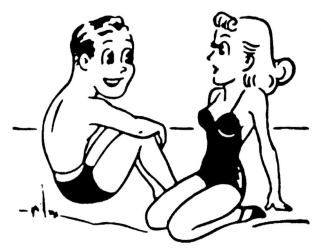

9

knees, and appears ready to speak or may already be speaking. The girl leans back on her hands, but seems somewhat tentative about the guy's intentions. As visual characters, the couple can be used to signify broad concepts like *beach, courtship, youth, leisure, Southern California, conversation,* and *intimacy.* In theory, despite their self-absorption, the couple is still available for interactions with unrelated graphic figures, but in practice, this may be no more than parallel play. Characters placed in the same visual orbit may never trespass into each other's abstract terrain, at least not without the support of dialogue, scene directions, or the imaginative projections of the reader.

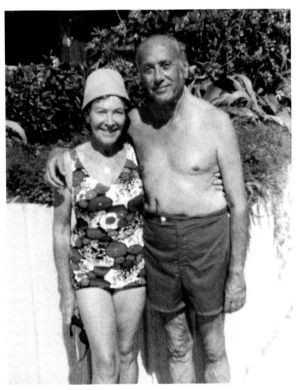

This photo pictures another beach couple, my great aunt and uncle posed in the garden of their Miami Beach residence hotel circa 1975. In contrast to the guy and the girl, they face the viewer (and the camera) and there is nothing tentative in their body language or affect. This has something to do with their age and the acceptance of imperfect bodies that are not on display for others, or for each other. They have made a commitment that the guy and the girl may not have contemplated. As a couple, they can be seen as emblematic to the extent that they represent the satisfying leisure that retirement might bring, but they lack the style and enthusiasm to be ideal contemporary models for the glories of luxury condominium living.

Roland Barthes in his book *Camera Lucida* examines the qualities in photographs that give them both a documentary weight and a metaphoric and psychic charge. He speaks of the sense in which the photograph takes a stance, adopts a pose, in the photographic moment of a portrait, event or scene. Barthes calls this quality "that has been", a "superimposition" of "reality and of the past." (77) In contrast, we are not likely to assign the presence of reality to the clip art beach couple, even if their graphic style references an earlier time. Still, they share a moment within a narrative space in time and it is possible to imagine that the photo documents the culmination of the beach couple's successful courtship and long-term marriage. Frozen for all eternity in their bathing suits and youth, the clip art couple—unlike my aunt and uncle--has nothing but time ahead of them.

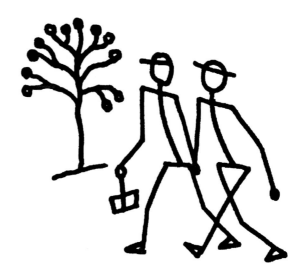

"Dress a stick in finery, it will also have charm."

Walking in the vicinity are a stick figure couple who seem to be both physically and emotionally attached. They appear deep in conversation. Even less likely than Doris to graphically fit in with the beach crowd, their forward motion gives them a claim on the white space to their left as measured by the distance from the book's gutter or edge of the page. Even the fertile tree in the background seems to bend to their presence. Has it been affected by a shift in the wind, or is it listening to what they say? If there is any ambivalence to the couple's relationship, it is centered on gender. Is this a boy/girl, boy/boy, or girl/girl couple? Locating them back in the era Doris, Dickie, and the beach kids inhabit, heterosexual infatuation would have been the norm portrayed. But looking at this image now, it is easy to see other options. Another anomaly is the baseball cap on the left-hand figure. Either it is being worn backwards and he or she is looking towards the other figure, or frontwards and he or she is looking straight ahead down the path. Also, the backwards cap mimes a version of hip hop or fraternity boy style that sends the vintage stick figure hurtling into the present.

Like the couple on the beach, the stick figure couple can be used to signify general concepts like *relationship*, *infatuation*, and *conversation*, but because they are in motion, they also incorporate the element of time. The stick couple begin their walk on one page, and when they reappear later we could reasonably assume that their conversation has progressed, much as this Introduction is proceeding towards some inevitable, yet still largely undefined, goal. As with many of the images used here, the stick couple endorses the premise proposed by the Yiddish proverb inserted underneath--"Dress a stick in finery, it will also have charm"--that visual embellishment can enhance the sensory pleasure of an idea, but will not necessarily make it credible. In this case, though, the caption requires some identification as well: Is it part of the stick couple's conversation or a dismissive comment by the omniscient author about their fragile body types, style, and demeanor? It is worth creating uncertainty if it puts the reader in a critical frame of mind.

11

ARE WE STILL ON THE SAME PAGE?

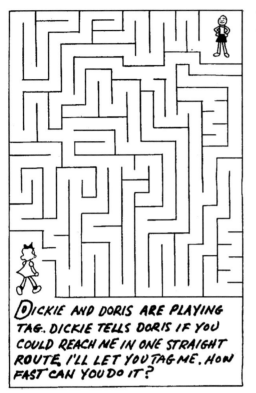

DICKIE AND DORIS ARE PLAYING TAG. DICKIE TELLS DORIS IF YOU COULD REACH ME IN ONE STRAIGHT ROUTE, I'LL LET YOU TAG ME. HOW FAST CAN YOU DO IT?

Through its "sensory fields" and its whole organization the body is, so to speak, predestined to model itself on the natural aspects of the world. But as an active body capable of gestures, of expression, and finally of language, it turns back on the world to signify it. (*The Primacy of Perception*, Merleau-Ponty, 7)

In this view of the full maze, Dickie waits and Doris pursues in a game of slow-motion tag. It has taken a few pages to see the roots of Dickie and Doris' graphic circumstances, but their reunion is a way to locate them in the collective inventory of the text. To draw the correct path, the puzzle player needs to focus on the pattern from above, not empathize with Dickie and Doris' personal needs and intentions. Still, that kind of identification may enhance the puzzle's kinesthetic effects. Playing tag is about adjusting to risk and uncertainty, negotiating achievable goals while acknowledging the organizational flexibility of a dynamic space/time map.

An important antecedent for **24 IDEAS** is Paul Klee's *Pedagogical Sketchbook*, a guide to his 1925 Bauhaus course on design theory. Built around a series of drawings and diagrams that illuminate his approach to the visualization of time, dimension, and space, Klee grounds his lessons in the study of lines, structures, systems, and dynamic forces in nature and science. Like the *Pedagogical Sketchbook*, **24 IDEAS** is meant to both teach *and* advance an intellectual argument, making its

case systematically, establishing a rhythm and holding ground in ways that both reflect and assert its convictions.

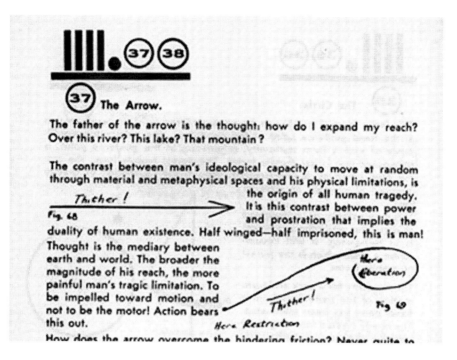

For Klee, the graphic arrow described in the above diagram is the symbolic expression of "reach," or imaginative potential. It embodies thought and action but is leavened by a tragic limitation: the imperative to dream and create does not give humanity ultimate control over the cosmic "motor" of fate. While many examples in the *Pedagogical Sketchbook* are located in the workings of commonplace things (bones, muscles, hammers, wheels, scales, spinning tops) every description is defined by Klee's iconography. So in a sense, he has created a system in which at least the motors of self-expression are very much in his control.

This is a picture of an arrow. A sign that literally performs **pointing** and **directing**, the arrow has attitude but does not coalesce into character or scene. It is both static *and* in motion: an iconic representation of a projectile in flight; an index that references location, direction, and varieties of contextual links; a

symbol that reflects the unbounded dimensions of time and space; and a metaphor for motion, intention, and speed. The arrow insists and suggests, and is open to guidance and manipulation. Graphic stand-ins for the pointing finger and the emphatic voice, arrows exemplify the orienting impulse of the sign.

> Doubt is a beautiful twilight
> that enhances every object.
>
> 10 18 24 32 38 46

This is a digital scan of a fortune cookie message. While it is an artifact of reality, it is less a model of experience than a philosophical ideal to live by. If its numbers apply, it is also a ticket to winning the lottery. Doubt's twilight is "beautiful" because it marks a transition between states of transience and revelation, disappearance and appearance, nothing and something. Doubt is also beautiful because it joins projection and rumination to guide the book's path, pointing forward and backward in book time.

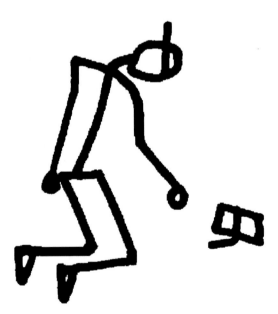

It is this contrast between power and prostration
that implies the duality of human experience.
Half winged—half imprisoned, this is man!

(Paul Klee)

14

1. A PICTURE IS IN FACT A LESSON

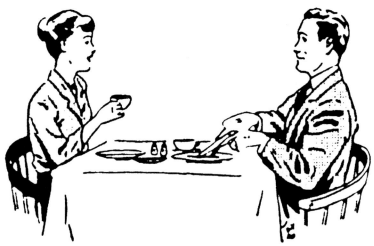

Next, said I, here is a parable to illustrate the degrees in which our nature may be enlightened or unenlightened. Imagine the condition of men living in a sort of cavernous chamber underground, with an entrance open to the light and a long passage all down the cave. Here they have been since childhood, chained by the leg and also by the neck, so that they cannot move and can see only what is in front of them, because the chains will not let them turn their heads… (Plato's *Republic*)

The gap between observation and interpretation is a very old story. Plato's *Allegory of the Cave*, whether seen as an embodiment of the mind's bedeviled search for knowledge or a prescient critique of any night in front of the television, pictures an ideal narrative of enlightenment that aligns with some determinate facts of common experience: when there is a way in, there is usually a way out; after the dark, comes the light; "this contrast between power and prostration."

In the image above, the ritual of a meal, the table and its objects, the gestures, expressions, and dress of the man and woman, the empty but charged space between them, and the reduced style of illustration combine to form its visual grammar. Plato's text is drawn in as commentary and possible dinner table conversation, but the authority of the boxed headline weighs heavily on the scene as a promise and a challenge.

Characterizations of the unique and the everyday are inextricably bound by the need to define what they are not, but could be.

"Nothing" presupposes a "something" that is somehow absent. So to be "in the dark" or "at sea" perceptually or metaphorically is not only to be denied visible confirmation of events, or a clear orienting lifeline out from a space that appears to lack boundaries or dimension. It is to have the expectation that a coherent path, a light at the end of the tunnel exists somewhere waiting to be found.

To live together in the world means essentially that a world of things is between those who have it in common, as a table is located between those who sit around it; the world, like every in-between, relates and separates men at the same time. (Hannah Arendt, *The Human Condition*, 48)

As Hannah Arendt describes, the same table that proposes relationship also engenders separation. The sensitive rituals and negotiations that routinely govern the design of tables at conferences of peace and war suggest that a codified *place* at the table is no less fraught than the table settings or the seating chart.

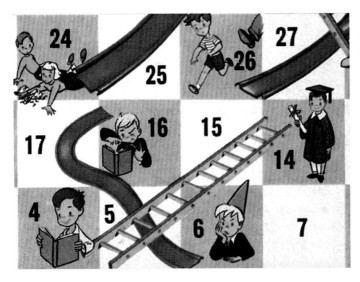

Like the dinner table, the square gaming table and folding game board present a boundary imbued with social goals. While meals are only occasionally structured for symbolic purpose, most games are wedded to specific sets of rules and obligations that lead to differing visions of success, failure, and community. The card

table--even when masquerading as a blanket on a lawn--focuses action at its center, but it is the edges that provide sanctuary for strategy and retreat. On your side of the table you learn to play the hand you have been dealt, sometimes by holding your cards close to your chest. The red and black squares of the checker or chess board prescribe navigation and the placement of surrogate markers and warriors, but classic game boards like those for *Monopoly, Chutes and Ladders,* or *Go to the Head of the Class* are veritable manuals of appropriate behavior and social philosophy: portable classrooms teaching upward mobility and family values, disciplined by the realities of negotiation and risk. What goes up, can go down.

> *You've got to know when to hold 'em,*
> *know when to fold 'em,*
> *know when to walk away,*
> *know when to run.*
>
> (Kenny Rogers, "The Gambler")

Apart from the high stakes combat of professional card playing, table games are spatial models in which the dilemmas of distance and relation between opponents are acted out and defused as play. Beyond the entertainment they provide and the life lessons they endorse, what games dramatically reenact is both the transience of human artifice and the wonder that even in their ephemerality, rituals and signs can coalesce into consensual language and meaning. On these pages, as the table represents a site for eating and communication, and Plato's cave and the monkey card back points of access or limitation, the reader is asked to map her own experience of tables, darkness, and games to a symbolic purpose. Through this identification with picture and text in the act of interpretation, the reader takes on its lesson.

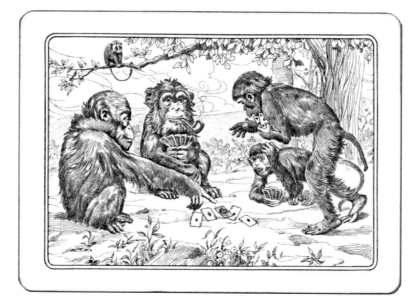

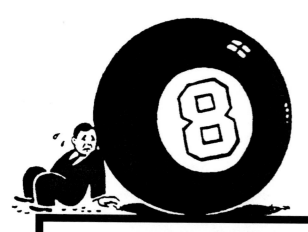

2. PICTURES HAVE CHARACTER

This clip art image of the proverbial man behind the 8-ball serves both a pragmatic and metaphorical function. By literally picturing an idiomatic expression, the image acts out the circumstances the words are meant to convey. The man in a suit and tie, sweating from cosmic anxiety or the immediate strain of holding back the oversized ball, is not only trapped in a difficult situation he can neither resist nor resolve, he is called on to represent the weight of an existential condition: the Sisyphean struggle between desire and fate here portrayed as a standoff on level ground. The man can't see where danger or redemption is coming from, even as he feels the pressure bearing down from behind. He also stands the risk of being pushed over the edge of the text box.

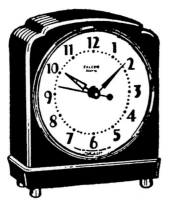

Clip art, a collection of copyright-free graphic icons available for commercial and private use, takes a flatfooted, declarative stance in regard to form and content. If the clip art image has an inherent agenda and will, it is to reaffirm the conventionality of its base as a visual cliché. Designed to adapt to whatever textual or presentational context is required, each image must be able to invoke a specific idea or point of reference without excessive nuance or diversion. If a community newsletter needs to indicate a schedule of upcoming events, then a graphic of a clock or calendar may be inserted to signify time, but this will have more to do with identifying Time as a category of experience than the details of clock design history. The clip art image that represents an ideal, exemplar, or stereotype is by holding firm on its own rhetorical ground essentially neutral in regard to any communicative outcome. It is a platform for expression, and has nothing to gain. The desk clock image inserted here can be appreciated for its sober aspect, its illustrative function as a nostalgic sign of time, or for the narrative benefit of bringing a specific time--10:09--to bear on a temporally nonspecific event, the reading of this page. In the midst of various theoretical assertions and speculations, the clock's face has no opinion.

The best clip art embodies a kind of deep shallowness that is signaled by its self-effacing adaptation to the suggestions and needs of the text. This serves the reader in important ways. First, each example inherits and carries forward a particular set of cultural beliefs, associations, and attitudes. Second, once engaged each image plays a transitional, mediating role between past expectations and present contingencies. This means that

21

the reader's willingness to consider a picture in a reflective or critical way makes interpretation an act of negotiation in which the picture proposes a transfer of obligation. From the perspective of artists, designers, or art historians, then, the decision to use pictures to manipulate the reader's sympathies and judgments is a gift both generous and opportunistic.

Also, opportunistic is the designation of a defined number of IDEAS to explain the multifaceted work of pictures in this book:

Why in this case, 24? Well, why 10 commandments, 7 Deadly Sins, or 3 Stooges? There was opportunity, there was trial and error, there was the self-justifying logic of an argument in search of exclusive terms. Finally, there was the need to suggest both confidence and humility: perhaps more than 24, but certainly not less. With persistence and good timing, theory or rank speculation can be made to seem both inevitable and true.

The man behind the 8-ball is tied to the circumstances of this lesson and the rules of pocket billiards. But like all clip art pictures, he has a defined character that flows from his graphic style and specificity of detail. The artist employs a line of attack through the

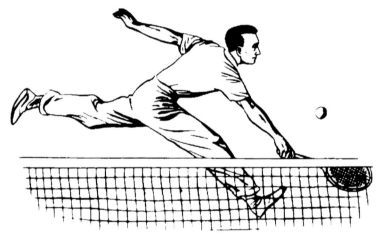

weight, tension, and qualities of drawn lines and shapes. This particular line reflects both a sense of the subject's character as well as the attitude in which the artist chooses to characterize its terms: the chunkiness of the man's shape corresponds to the density of the 8-ball. In contrast, the tennis player is at leisure and would seem to be free of the intense pressures of the man behind the 8-ball, or the stolid responsibilities of the clock. His balletic motion is mirrored in the lightness and delicacy of the net, mitigating the uncertainty of whether he has or will make successful contact with the ball. This is a case where form trumps function.

I'd like to help you out.
Which way did you come in?
(Henny Youngman)

3. PICTURES LOOK YOU IN THE EYE

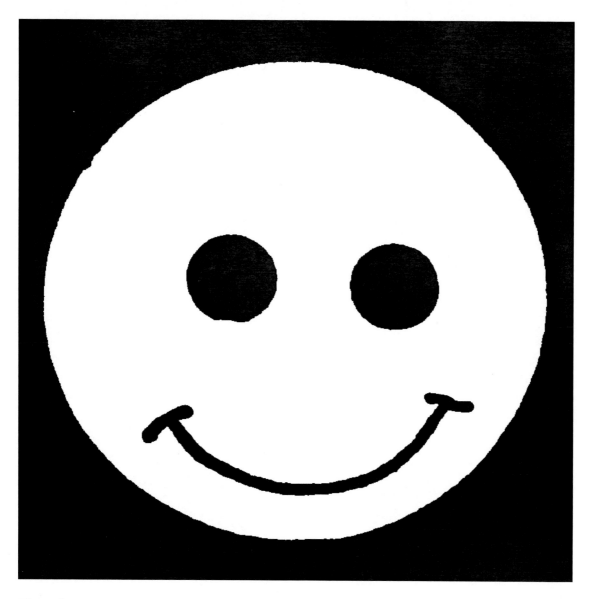

The ubiquitous Smiley Face is all intention. Initially part of a 1964 campaign to encourage positive employee interaction at an insurance company, it has been used to pitch movies, products, and political agendas. Sometimes the Smiley Face serves as a sign of hope, and other times as a foil for the debasement of false optimism. According to his obituary in the April 14, 2001 *New York Times*, Harvey Ball, while paid $46 by State Mutual Life for the original design, failed to copyright it and so it fell into the public domain, where it has been flogged and exploited by a multitude of entrepreneurs and artists ever since. Recently, in an instance of rapacious good cheer aligned

with aggressive marketing, a series of television commercials for Wal-Mart has Smiley dressed in a black wide-brimmed Zorro hat and mask fighting for the beleaguered consumer by slashing prices with a sword. As a symbol it seems inexhaustible. How does it do its work?

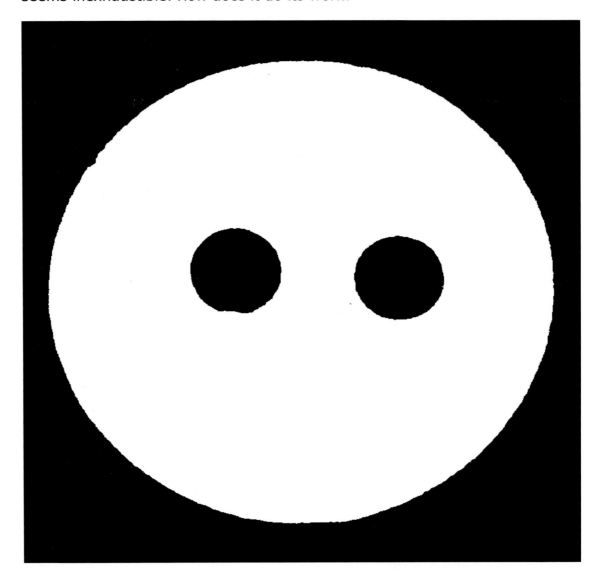

Lit by the arc of its smile, but grounded in the blank stare of its eyes, the Smiley Face demands attention. While it is the smile that provides the hook, the eyes dominate the exchange. This is easily tested by eliminating the mouth: the eyes become expectant, sad, confused, as Smiley loses the ability to speak. Or eliminate the eyes, in which case the Face appears blind. The Smiley Face used in this lesson was rescued from wrapping paper attached to a hanger from my former dry cleaner in New York City. Like all such faces it refers back to other versions of itself, but what makes it a triumph of *generic* engineering is its apparent freedom from any valued or identifiable original. Each new Smiley Face, like each new loaf of bread born from a stock of generative dough, makes its own way. Yet, despite the banality of its appearance and relentlessness of its use, the Face remains a

provocation--part joke, part irritant, part dare. It sucks all the critical air out of the moment, drawing a conflicted response while remaining unselfconscious in its blatant appeal: "Let me in."

The Smiley Face is emblematic of the task offered to the viewer encountering many images--a relationship I would characterize as *a call in anticipation of a response*. Whether representational or abstract, the image is asking the viewer to consider *something*. And if the viewer takes the bait, her encounter, and the reading and interpretation which follows, shapes the course of its meaningful trajectory as a sign. A circle, two dots, and a curved line read as a face with thoughts and will. The eyes lock on yours. Glare back and the dilated pupils, shilling for the smile, have you cold. They read as blank because of what they don't reveal about the intentions of the face, and because their graphic depth--two deep pools of blackness--imply something hidden. Proverbial windows to the soul, the eyes are signs of absence and presence, lack and potential, oscillating impressions cast as interlocked polarities. Blind faith.

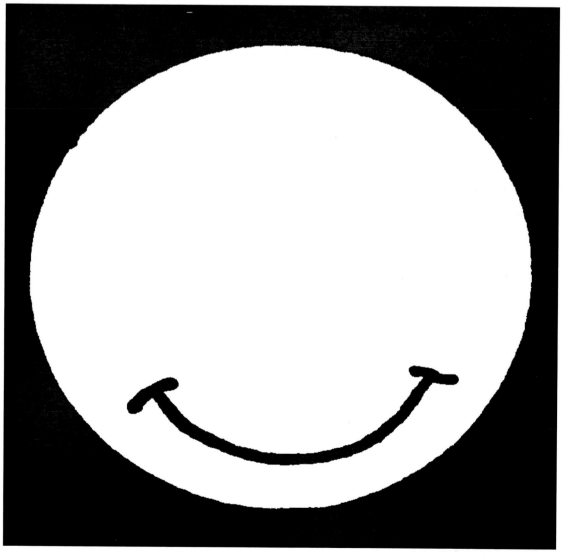

4. PICTURES MEASURE AND REFLECT

2.151 Pictorial form is the possibility that things are related to one another in the same way as the elements of the picture.

2.1511 *That* is how a picture is attached to reality; it reaches right out to it.

2.1512 It is laid against reality like a measure. (*The Tractatus*, 9)

Consider this picture of a ruler as a set of facts subject to certain criteria of value: a tool reliant on defined conventions to calculate and characterize distance, size, and relative scale. If we are intimate with the rules that govern its use, a ruler provides an important descriptive service. It not only calculates the dimensions of a single object, but makes possible the alignment of one part to another in more complex schemes. Yet if, for example, it is divided into inches and centimeters are required, or if the scale of the ruler is many times smaller or larger than the scale of the task, or if the ruler is observed from such a distance that none of its details are clearly visible--other than the fact that it resembles other rulers--an evaluation of its usefulness would be thrown into disarray. The ruler becomes symbol, even as it retains its connection to the lineage of measuring and measurable things.

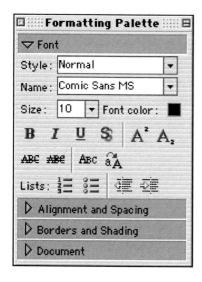

In C.S. Peirce's semiotic system, an **INDEX** signals the presence of an object, phenomena, or relationship in which the **INDEX** plays a facilitating role: smoke is an **INDEX** of fire; pail and shovel are an **INDEX** of the beach; a ruler is an **INDEX** of measurement. On a computer screen, the various cursor icons are **INDEXES** that make a claim on a word or image through selection, highlighting, dragging or linking to other files, tools, or programs. The adjacent Microsoft Word "Formatting Palette" controls and measures the qualities of type and format for this paragraph, while **INDEXING** the essential presence of word processing as a requisite tool for building a text.

27

The first lesson in Paul Klee's *Pedagogical Sketchbook* concerns the "active line," a fundamental element in art, design, math, and science inherent to the visualization of shapes, processes, quantities, and things. A line is an index for degrees of order, connection, and precision.

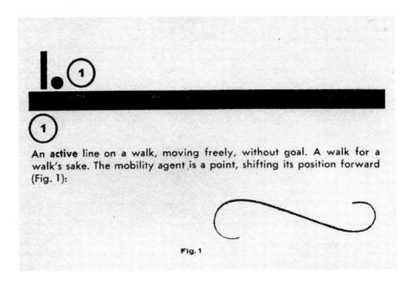

An **active** line on a walk, moving freely, without goal. A walk for a walk's sake. The mobility agent is a point, shifting its position forward (Fig. 1):

Fig. 1

If pictures measure and reflect, and lines are fundamental elements in many pictures, what do lines measure and reflect? To begin with, a drawn line reflects the presence of the hand: a graphic record of a physical gesture or impulse generated by the arm and wrist. Sign on the dotted line, X marks the spot. For artists serving the discipline of representation, the line becomes a measure of skilled **hand-eye coordination**.

In Klee's walk taken by a mobile point, interpretation requires that viewer's form a meaningful equation between a physical event and its abstract record. By characterizing a line as the product of "**a point shifting its position forward**," Klee introduces the element of **time** integral to understanding the crossing of **space**. This, in turn, incorporates the belief that time moves in a *future* direction towards some goal or limit.

The intellect in action

(*The Book of Signs*, Rudolf Koch)

Finally, when Klee identifies this particular active line as "**without a goal**," a "**walk for a walk's sake**," he is suggesting the lack of a defined artistic end although in truth the line is being used in support of a specific pedagogical lesson. **"Glory, glory hallelujah. Teacher hit me with a ruler."**

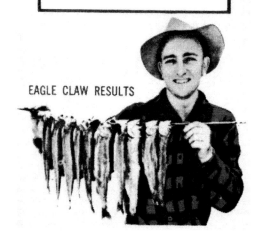

EAGLE CLAW RESULTS

So rulers, indexes, pictures, and lines all reach out to reality like a measure, but they also draw connections from one agenda to another. This image from a package of fish hooks has "positive hooking qualities," making its case by presenting hard facts: ten dead fish hanging on a line. The smiling fisherman has used this product to achieve measurable results which reflect well on his skills and the product's effectiveness. The body in action: Given the right tools and focus, drawing lines, like recreation, can be both stimulating and productive. And so the stick figure on his knees at the close of the Introduction is here renewed.

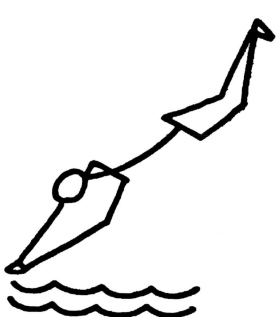

This drawing scanned from a book about indian pictographs and sign language (See 7. **PICTURES ADOPT A POINT OF VIEW**), is an index of vision, foresight, and prophecy. The character faces right, either staring with intensity and hope to the future, or in a more limited way directing the reader to the next page. The dashes emanating from his eyes bear a family resemblance to a cartoon of an invisible ray which, like the Eagle Claw, pulls whatever it sees in the "direct line of pull."

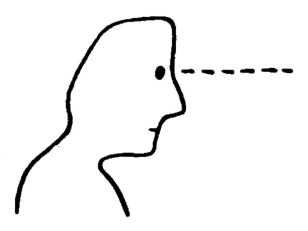

5. PICTURES STAND BETWEEN

It is assumed here that the task of reality-acceptance is never completed, that no human being is free from the strain of relating inner and outer reality, and that relief from this strain is provided by an intermediate area of experience which is not challenged (arts, religion, etc.). This intermediate area is in direct continuity with the play area of the small child 'lost' in play.

(D.W. Winnicott, *Playing & Reality*, 13)

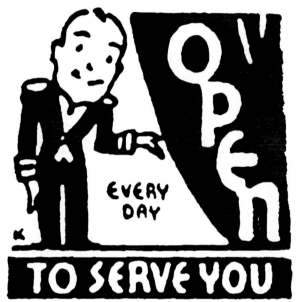

Drawn into active use, a picture can be deferred to as a kind of evidence or example: an adaptable bargaining chip through which a wager can be placed on selected versions and visions of the truth. Whether meant to flatter, compel, or shock their audience, pictures stand between like a membrane or a mirror to mitigate or amplify the "strain of relating inner and outer reality." But they may also, as with art and propaganda, seek to deny that there is a conflict.

The clip art doorman is a synthesis of three strategies: it acts out a possible event from everyday experience; it attaches an ideal or conventional meaning to that circumstance—in this case emphasizing the doorman's promise to serve; and, finally, it uses a graphic style and characterization to locate its message within a particular emotional and cultural frame: a doorman, like a salesman, is assumed to be both calculating *and* obsequious in his quest for success, so the cartoon smile, service uniform, and open palm can be read as both demeaning and disarming. First making its appearance in the Introduction, the doorman also represents the purposeful, aggressive stance of other images that need to be wanted.

I referred to two objects as being both *joined and separated* by the string. This is the paradox that I accept and do not attempt to resolve. The baby's separating-out of the world of objects from the self is achieved only in the absence of a space between, the potential space being filled in the way that I am describing. It could be said that with human beings there can be no separation, only a threat of separation. (Winnicott, 108)

31

D.W. Winnicott's metaphor of the string is a theoretical bridge linking connection and separation. Strings span, bind, and extend. They can be held taut or left hanging. You can string together a collection of beads, string someone along, or lose the string of an argument within a train of thought. In an exercise Winnicott used with his young patients called the "Squiggle Game," he sets the drawn meandering line (kin to Klee's active line on a walk) the task of generating associative connections. "This squiggle looks like a..." On this page, the cowboy's lasso and the fisherman's line are both extensions of the body and symbols of its limits, hopes, and fears. As with Paul Klee's arrow--"How do I expand my reach?" Even with wireless phones, we stay on the line, yet may not be assured of a good connection.

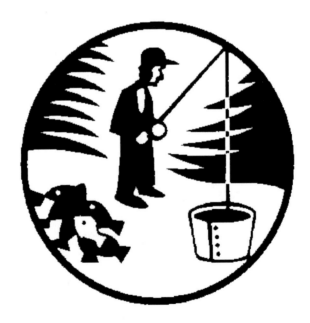

In "The Fate of the Transitional Object," Winnicott explains the significance of transitional objects for the infant in relation to two points: First, the transitional object arises as an extension from the sensation of the mother's body, leading to the acceptance and manipulation of physical objects: i.e., the infant's oral experience of fist and thumb is ultimately transferred to the handling and evaluation of things. Second, the transitional object becomes phenomenally present and meaningful in the world through the infant's

mapping of a "hallucination"--an imaginal connection--onto it. "The infant gains the illusion that the world can be created and that what is created is the world" (*Psychoanalytic Explorations,* 53). This mapping of the image or object to the perception or sensation that it represents corresponds to the infant's developing ability to assimilate knowledge through manipulation and play. Signs are made to seem authentic by their facilitation of transitional acts, whether these are gestures that clarify the separation of the self from the world of things (the me from the NOT-ME) or acts of imagination that blur that line. For Winnicott, people can live with the threat of an unbridgeable gap between lived experience and the sign, but the gap is ultimately unacceptable.

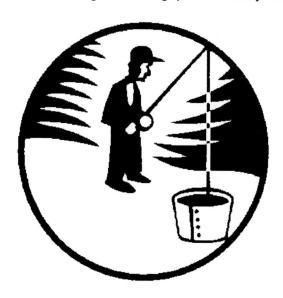

This drawing by Anthony Ravielli from the 1958 *Sports Illustrated Book of Baseball* presents a narrative that the viewer is invited to complete. It pictures New York Yankee pitcher Sal Maglie who, in mid windup, represents the viewer's perspective and perhaps desired bodily expression--this scene is, after all, intended to be both instructional *and* inspirational. But it is the anonymous catcher facing the viewer who absorbs the impact and weight of the moment. Specifically, a baseball is about to be thrown. More generally, the picture serves as an index of intention and potential. The catcher provides the available target, and the audience's identification with Maglie's stance and concentration sets up the exchange.

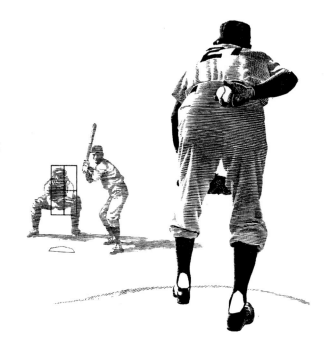

If I toss a ball in your direction, I do so with the expectation that you will try to make the catch and accept my invitation to play.
PLEASE DON'T HANG UP!

6. PICTURES ARE SELF-SERVING

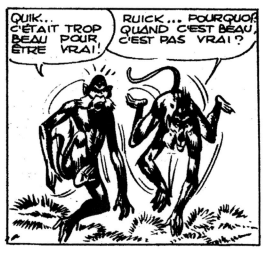

In this cell from the French comic *Akim, Le Temple des Ombres*, the upright monkey says: "It is too beautiful to be true." The monkey standing on his hands replies: "Why, when it's beautiful, isn't it true?" For the reader, as for the monkeys, an evaluation of an event is followed by an evaluation of the evaluation: something judged as momentous has occurred; there is surprise that the outcome was good; then there is surprise at the lack of faith in the truth of a beautiful result. Akim is a Tarzan-like hero with a host of animal friends. This dialogue, which follows his rescue from a marauding tribe, calls attention to a problem that haunts much visual and verbal interpretation: the expectation of some balanced accommodation between sensation, perception, public meaning, and personal judgment.

In *Understanding Comics*, Scott McCloud explains and analyzes the dynamic web of word and image in the comic book form. Looking pragmatically and philosophically at the comic's graphic and narrative conventions, he takes on the problem that an analysis of visual culture demands: the objects and rituals of culture can't fully be understood or explained from outside the experience of their effects. In this example, the author speaks and the icon replies, as the picture reiterates its own terms. In the left frame with his back to the reader the

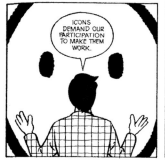 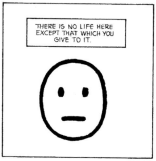

character representing McCloud stands before the icon of the face and graphically supplies its nose and mouth. In the right fame, the unsmiling, disembodied face floats alone anticipating the reader's reply. For a picture, "there is no life here except that which you give to it."

The image of the boy preparing to wash his hands is taken from the same Taiwanese primer as the block builders shown in the Introduction. That the boy might be thinking about **this page** is no less unlikely than that it reflects the unmediated thoughts of its author. Everything pictured and described **here** is cleansed of accident, and calculated for effect as are most image-free pages of text, yet this scene should also be understood dramatically as occurring both **on** the here of this page and **in** the here of this moment. While the rhetoric of speculation and judgment may sometimes require protection from facts and distinctions that do not completely serve its needs, the struggle to shape an argument is still beautiful.

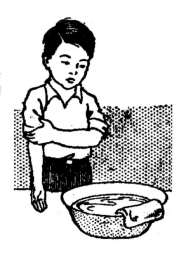

35

7. PICTURES ADOPT A POINT OF VIEW

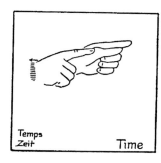

Temps
Zeit
Time

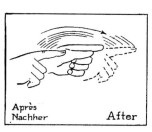

Après
Nachher
After

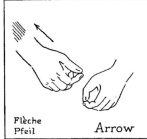

Flèche
Pfeil
Arrow

The above illustrations are taken from *Indian Sign Language* by William Tomkins, a reprint of a 1927 book cataloguing pictographs and hand signs attributed to various tribes of North American Plains Indians. In his introductory notes, Tomkins, who was in active contact with the Sioux throughout his life, makes a distinction between Indian signing and the sign language of the deaf:

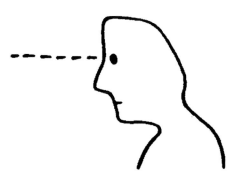

One very wide difference between the Indian Sign Language and the signs used by the deaf and dumb is shown in the word THINK. The originators of the Indian signs thought that thinking or understanding was done with the heart, and made the sign "drawn from the heart." Deaf mutes place extended fingers of the right hand against the forehead, to give the same meaning. (*Indian Sign Language*, 8)

Whether thinking is described as knowing (head) or feeling (heart), the salient issue for Indian sign language is that it is made up solely of verbs and nouns, actions and things, and primarily referenced to the gestures and routines of everyday life.
As shown above, the expression of metaphysical TIME is modeled on the setting and pulling back of the bowstring. AFTER, or *future* **time, enacts the release and presumed path of the invisible arrow. The ARROW, anticipating its function in time, is signed by miming the selection and withdrawal from a quiver.**

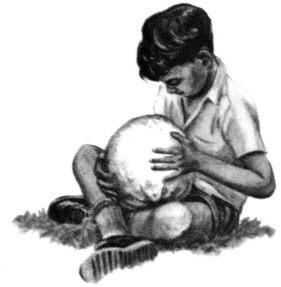

Head and heart: the seeing man pictograph thinks back to his earlier appearance in the book, while the boy holding the giant mushroom sees and feels with his hands.

37

In "Theses on the Philosophy of History," Walter Benjamin projects Paul Klee's 1920 painting *Angelus Novus* as a visual allegory of the inevitable destruction of material nature that a blinkered belief in historical progress ignores. In this formulation, the painting's single figure--the new angel of history--hovers in space with his back to the future, where he has been driven by the "storm from paradise" (Eden)--a storm "we call progress." Looking back to the past, compelled to watch the rejected artifacts of material culture accumulate like rubble before him, the angel represents the dilemma of the historian whose desire to confirm a pattern and purpose to time and history is denied by the relentless flow of events, and the scattering of facts and opinions displaced from their sources.

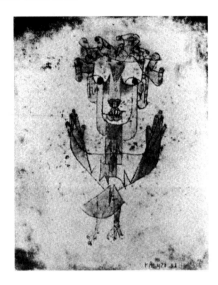

To the viewer standing in the "past" outside the painting, the new angel appears transfixed like a deer caught in the headlights. But the angel, whether paralyzed by despair or bravely calling out the alarm, at least seems to be facing up to the problem.

Under these fragile circumstances, then:

Why did the Moron take his ladder to school?
He wanted a higher education.

The businessman with his smile and confident stance looks up at the chart. He, too, has a positive attitude as he points to the top, where the chart visualizes the path of a rising trend. Things are looking up! The Moron, for his part, ignorant or unafraid of the "storm from paradise," chooses to literally climb the ladder of success, not just observe it. For the sake of a higher education, he steps into metaphor at the point where language and experience call attention to a cosmology meant to encompass both of them: the past is prelude, the future is bright. It seems like just yesterday. This could go either way.

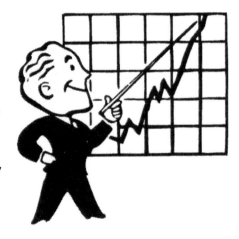

8. PICTURES RELY ON AN INVENTORY OF EFFECTS

Hi, My name is Tina. I am a Las Vegas Showgirl. When I'm not working, my friends and I love to talk and make new phone friends from around the country. Will you be my phone friend? Call us just once and we will always be there for you. Love, Tina.

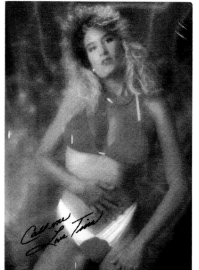

"Tina" appears on a phone sex postcard, its arrival no less provocative for being unanticipated junk mail delivered to "Occupant" at my home address. Pictured with bleached blonde feathered hair and a dreamy, distant look on her face, Tina is caressing her body and thinking of "you" and "me." Playing the dual role of seductive spider and willing prey, the purring insincerity of her print voice is domesticated further by its presentation in simulated handwriting. Amazingly, this appeal for phone friends is described as something other than work, but it is even harder to imagine anyone believing that Tina and the other showgirls will "always be there." What doubts and expectations is this pledge meant to assuage? Where is "there"?

Since the graphic and narrative target of this proposal is the red diamond on Tina's bikini bottom--or more precisely, what the shape marks and conceals--her coy, little girl passivity invites aggression, possession, and frustration. The caller's desire is guided by the magnetic focus of Tina's crotch, the location of her handwritten signature and the goal of "friendship" which will most certainly be denied. As the Van Heusen/Burke song goes: "Imagination is funny, it makes a cloudy day sunny..."

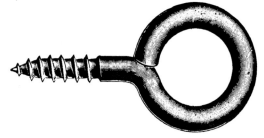

In referring to images as *pictures*, 24 IDEAS often blurs the line between the idea of a picture as imagined or expressed in words ("Picture this!") and concrete visualizations also called pictures ("Here I am at the Grand Canyon") on which many verbal assertions rely. A picture, as Wittgenstein defines it, does reach out to reality like a measure, but it also shades how

reality is viewed. While we may see this illustration of an I-screw as an accurate representation, even one that formally combines male and female sexuality, in American English speech a screw has more to do with the predatory imaginations of Tina's potential friends than hardware.

> It makes a difference to the way I feel about a new female acquaintance if a colleague, having caught sight of her, remarks on her beauty or her plainness. There is a double irrationality in this. In the first place, my feelings should not be so dependent upon a women's appearance. I know that, and I apologize. But I still feel it. The second thing is that it is surely a deplorable lack of independence on my part to be so affected by a criterion which can be of no significance to me. (John Hull, *Touching the Rock*, 23)

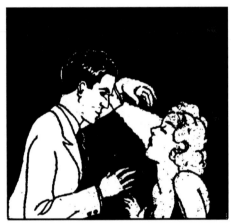

In a world made for those with sight, blindness is a severe trial that requires profound realignments of expectations and skills, public and private. *Touching the Rock*, John Hull's diaristic account of his descent into blindness, casts a dazzlingly clear critical light on the prerogatives of vision, in particular the degree to which the eyes explain and justify encounters with the environment and other people. In the above quote, Hull recounts the persistence of stereotypes that inform his relationships with colleagues at his university. Despite the loss of the vast inventory of signs and signals that the sighted can claim, Hull suggests that the blind are also subject to the distortions of bias, projection, and "insight."

> This close association between image and desire reminds us that sight is an anticipatory sense. The anticipation of satisfied hunger replaces the sensation of hunger itself. As the need and its fulfillment come into focus upon the image of food, activity is aroused. (*Touching the Rock*, 49-50)

Focus on the black spot between the Dot and the mouth. Aim your nose at the spot and slowly move the package toward your face. What happens to the Dot?

Isabel wasn't too thrilled with the abstract art, but as for the artist...

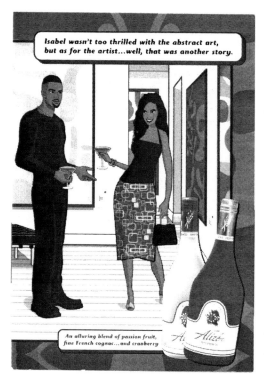

Imagination can redeem both art and money, but as this postcard for Alizé liquor describes, it runs a poor second to sex and dating. Dispensed on racks adjacent to restrooms in sophisticated restaurants, this takeaway ad makes its pitch through an alliance of lowbrow pandering and hip style: Abstraction is for suckers. (See **20. PICTURES ARE SCAPEGOATS**) As with most advertising, the picture is defined and constrained by its caption or tagline. But whether hunting for love or food, the picture is the mechanism expected to bridge the gap between image and desire, thereby also drawing the split into focus and question.

Two dumb guys go bear hunting,
They see a sign reading "Bear left,"
so they went home. (Henny Youngman)

9. PICTURES HAVE NO EFFECTS, ONLY ATTITUDES

This is 9th of 24 lessons, and in almost every case so far, pictures have been used as examples of types to be described and analyzed. While these lessons have been largely reliant on words to explain effects, the pictures have been placed center stage, somewhat distorting their significance and the text's essential role. Pictures function here like willing puppets posing and performing for the critical voice behind them.

In a conventional codex book where type is disciplined into "justified" galleys with uniform typeface and leading, the visual effects of typography are meant to support the idea that the book's form is a neutral, sober presence. When text is rendered in "print," it becomes a sign of knowledge. The calculations of the book's design recede so that the author's voice is all the reader must consider.

12 PT. SPARTON BOLD CONDENSED with BOLD COND. ITALIC

Type is the voice through which your printed salesmen speak. T
TYPE IS THE VOICE THROUGH WHICH YOUR PRINTED SALESMEN
1234567890$

(Type sample from the *New York Journal American*
type style manual, c. 1960)

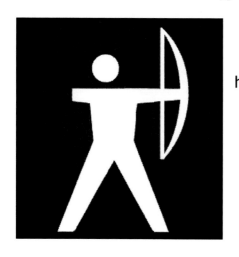

In 24 IDEAS, various shifts in typography are meant to project different voices, or at least different intensities of expression. The Author has many moods. But despite various distractions and bids for attention it is still a question whether the book ever escapes the domination of one insistent voice for very long. Parenthetically, this picture of an archer, which literarily takes a stance in relation to the text block, is in fact an element in a set of international signs that function as a typeface: print masquerading as image.

43

(Pause)

The dictionary describes a non sequitur as "an inference or conclusion that does not follow from the premises." Here are some pictures that propose disconnection from the responsibility to mean something coherent, but they are still being asked to raise an important question: Is a visual non sequitur a conceptual fact, or just a sign of cognitive exhaustion? Can a picture ever resist a definitive interpretation and just express an attitude?

CLOSURE IN COMICS FOSTERS AN INTIMACY SURPASSED ONLY BY THE **WRITTEN WORD,** A **SILENT, SECRET CONTRACT** BETWEEN **CREATOR** AND **AUDIENCE.** (McCloud, 69)

Everyday perception and interpretation is fueled by the forced eliding of inconsistencies and the synthesis of partial knowledge. The mechanism of "closure"--the reading between fragments, the leap across the graphic gutter--analyzed by Scott McCloud in *Understanding Comics* is not only the central principle of comic book law, but the conceptual glue that makes

chronologies of events seem tangible, purposeful, coherent: this happened next; ten years have passed. Closure brings narrative and event, cause and effect into effective use. It makes them believable. Therefore, signs of irrelevance and dislocation threaten the principle that things *must* fit-- somehow and somewhere--that coherence is not an illusion masking disorder, but the way things are supposed to be.

44

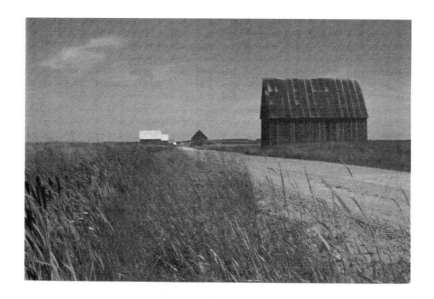

10. "A PICTURE IS A MODEL OF REALITY"

The delicate and hermetic world of the souvenir is a world of nature idealized; nature is removed from the domain of struggle into the domestic sphere of the individual and the interior. (Stewart, *On Longing*, 198)

Nostalgia is a sadness without an object, a sadness which creates a longing that of necessity is inauthentic because it does not take part in lived experience. (200)

This 1994 postcard photo of Sackville, New Brunswick, pictures a dirt road leading the eye in one-point perspective to an iconic peaked roof farmhouse in the distance. Soothing in both its understated depiction of rural beauty and its pointed reference to landscape painting, it is the Pachelbel's Canon of postcards, pretty enough to provide unassailable middlebrow aesthetic pleasure: the soft focus of the various farm buildings in the middle ground and the distance, the close tonalities of earth colors and the mottled blue sky. No signs of rural poverty here. When I saw this card in a discount pharmacy, it called out "picturesque," so I bought it.

Souvenirs can distort and trivialize local expressions with or without local encouragement, and be more a record of the tourist's tastes and values than hyped regional marketing, but retrieving the exotic or the picturesque for service at home also extends the narrative of the souvenir into new terrain.

45

The idealization of the Sackville scene would fit Susan Stewart's idea of the nostalgic souvenir as a black hole for thwarted or unconsummated contacts with the Real--except, as I look at the postcard now, I feel no longing for what it represents or where it was found. There are no expectations to be denied, except the desire to reclaim the span of years that have passed since the trip.

Picture postcards use their visual appeal and concise address to reach across distances, to keep friends and family *posted*, to acknowledge good fortune and good news. In this sense, an uninscribed and unsent postcard exists in a state of arrested development. The art reproduction postcard can have a full afterlife as a miniature drawing or painting tacked to a bulletin board or wall, but the unused postcard is a gift reserved for the tourist who collects it.

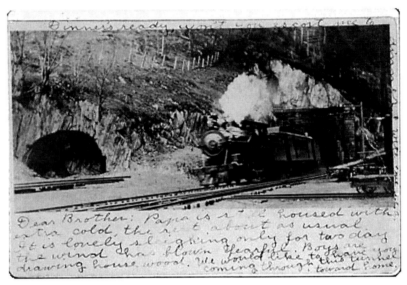

While rummaging around the bins of an antique store in Rutland, Vermont, in the fall of 1985, I came across a set of postcards from the early years of the twentieth century. Dated from August 1906 to February 1907, all were addressed to an Edwin S. Allard, then living in Custer, Michigan, and later Vistula, Indiana. Most were sent by family members in Vermont, a few were business-related. Of the thirteen cards, six are what might be considered generic tourist images--public buildings and scenic wonders--while the remainder were informal photographs of local scenes commercially produced as postcards--a waterfall near a mill, a street in the snow, a shingle-covered cabin. One of the Allard cards made its case in particularly poignant fashion, by drawing image and text into a collaboration where the visualization of space and time (documentation) recede before the longing for the *eclipse* of space and time (memory). While any photograph, as artifact, can be said to implicitly express that yearning, this picture speaks to it directly. News and casual conversation arriving by post and train set up the card's underlying plea:

Dear Brother: Papa is still housed with extra cold, the rest about as usual. It is lovely sleighing only for two day the wind has blown fearful. Boys are drawing house wood. We would like to have you coming through this tunnel toward home. Dinner's ready, won't you escort me to dinner?

The image combines a sense of expectation (the steam engine emerging from a tunnel in the foreground) with that of loss (the possibility that the train will continue, and leave its tunnel as vacant as the background one). The card's voice (Allard's sister Molly), in mirroring the hope and uncertainty expressed in the image, supports its intentions in both narrative and aesthetic terms.

Within the image, an event is unfolding that will soon pass. Two tunnels, two possibilities, are visible. The foreground tunnel is temporarily active (occupied), but the train will soon cross the train yard and pass out of the observer's visible range, beyond the camera's frame. The passive (empty) tunnel in the background proposes that trains may depart as commonly as they arrive. How recently did another train pass through, perhaps carrying the mail? The optimism and faith of the one who sends a postcard is tested, but this is not only because of the distance that must be covered and the unknowns associated with the postal system. Sending a postcard is an expression of defiance before the blank indifference of time and space to human needs. If there is an emotional center to the postcard image it is not the train in the tunnel, but the expectant tunnel behind. It is to that gap in duration that questions about past and future arrivals and departures may be addressed.

Send Reply

Molly Allard's postcard message ends: "We would like to have you coming through this tunnel toward home." That is, we would like you to appear, to become visible again, to be more than image or potential. And we ourselves, your family, represented by this token reminder of our shared experience, would like once more to become visible, wholly present, to you. Allard must cope with gaps and discontinuities that are hard to fathom in a present filled with the real-time disposable chatter of cell phones, pagers, and e-mail. How and why one looks into the lives of strangers as imbedded in their images and messages is a question for postal workers, historians, collectors, psychologists, and anthropologists alike, but Molly Allard's carefully calibrated expression of longing is a statement of profit and loss that can't be easily balanced or written off.

11. PICTURES ARE SENTIMENTAL

The author at age nine.

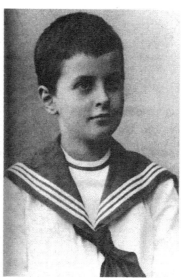

Ludwig Wittgenstein at age nine.

A photograph of oneself as a child, beyond recording a pose or event linked to a particular time and a place, provides access to a legacy of identity the child makes available to the adult. The content of this report from the past is of necessity shaped by the painful or nostalgic memories of the adult, which are in turn the product of character, biography, and education. For the child's legacy is not a prophecy, but a burden that makes demands. In the end, the snapshot image turns on the light of memory and speculation, providing a platform for whatever lies, idealizations, or insights the adult can project back on to it. Therefore, there is the hope that the reinterpretation of this visual evidence may provide some explanation for why an adult may grow up to become both a fierce critic and a willing captive of his image in a childhood photo.

NAME...

In the development of these traits, the home shares responsibility with the school.

TRAINING IN PERSONALITY Desirable Traits	1st	2nd	3rd	4th
1. Works and plays well with others				
2. Completes work				
3. Is generally careful				
4. Respects the rights of others				
5. Practices good health habits				
6. Speaks clearly				
7.				
8.				

MEANING OF RATINGS

S—Satisfactory U—Unsatisfactory

N—Needs Improvement

S°—Unusually high level of achievement

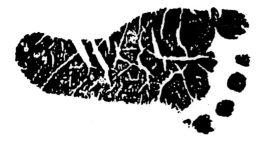

This is a print of a print of a print that marks the birth of one of my children as recorded on a hospital document. It is of course deeply personal for me, but also as a sign of human presence, broadly impersonal. The print literally measured a reality—the size of my daughter's foot—but also a specific point in time, her birth.

49

An imprint of a human body transferred to paper, later scanned to a computer and finally reproduced in a book. the footprint is now less a piece of evidence than an example of how a graphic symbol speaks to issues beyond its immediate terms. In contrast to a footprint marking the sand at a beach, this print is no longer a real time indication that someone has passed through and left a trace.

Pictured in mid-flight, this one-winged airplane was copied from "Catch the Monkeys and Other Games," a small booklet of pencil and paper games purchased in a local party supply store. It is one example from a page of simple drawings of partial things--a bicycle without handlebars, a clock with no hands, a table with three legs--which the reader is invited to complete.

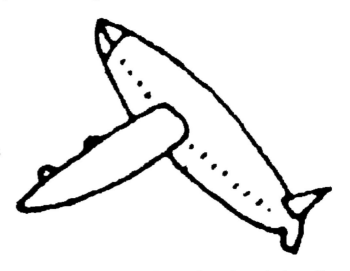

While the entire booklet is an exercise in restoring what is missing--the redemption of the fragile and the incomplete--the airplane has a particularly sad sweetness belied by its humble origins as a graphic casualty. Drawn with awkward, thick lines, vulnerable and hesitant in the air because of its one visible wing and the insufficient scale of its tail assembly, its nose reaches up expectantly in anticipation of sustained, controllable flight. Whether it appears to rise, hover, or fall, the airplane is more like a surfacing whale than a flying machine: a flawed model of an airplane representing the child's-eye view uninformed by the mechanics of flight. The airplane's hopes float on a wing and a prayer, even as it persists as a picture in copies of an obsolete party favor.

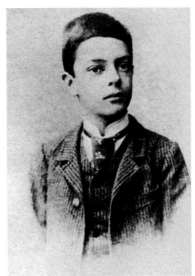

Paul Klee at age thirteen.

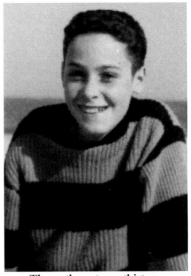

The author at age thirteen.

12. PICTURES ATTRACT AND REPEL

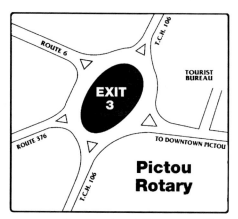

Pictou Rotary

Pictures are like magnets, intrinsically designed to attract and repel. I show you a road map of where I've been and it becomes an occasion for sharing both public information and personal stories and advice. As a document, the road map graphically measures space and distance, but it also provides the outline of a script to be filled in. The Pictou, Nova Scotia, diagram pictures the intersection of five roads whose crossing is marked by a black oval "EXIT 3." If it had no text description, the drawing would still provide a point of entry into and out of a graphic hole, the nucleus of a highway nerve cell with dendritic arms. By representing the experience of distance, or the nexus of events, the road map is in thrall to the things it describes.

Pictures are always in a state of anticipation: to draw is to represent and to pull something towards you. A picture of a magnet represents this effect, but it also requires an act of imagination to see it work. Wherever you place it on the page it appears to hold its ground, pulling adjacent words and pictures into its orbit.

This vintage matchbook cover presents a naïve, but comforting view of social cohesion. Gender roles are stable and the instructor, in cap and

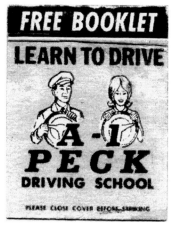

uniform, is presumably in control. But in whatever spirit the reader takes this bait, a new path is opened up for the picture's itinerant life as a sign. This includes being drawn into debate about the self-satisfied embrace of the present in the light of past values presumably cast aside; or, in contrast, a repackaging of that past as a useful legacy carried forward to the future. Who is in the driver's seat? Who wears the pants in the family? The souvenir lives through the associations of the collector, and some trace of the collector may be sustained through the survival of the souvenir.

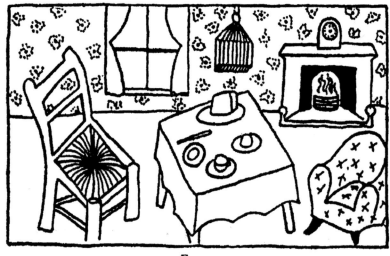

Fig. 5

> I found that to draw the line of one object with fully felt
> awareness of the line of a neighboring one and of the patterns of
> space that they mutually created between them, seemed as
> potent an act as laying a wire across the terminals of a
> battery...
> (Joanna Field, 12)

In *On Not Being Able to Paint*, Marian Milner (under the pseudonym Joanna Field) sets out to understand what it means to paint and draw. An avowed amateur, she decides to use her inexperience and lack of skills as a test case, to see if she can describe from inside the process both the mechanics and the perceptual understanding necessary to produce a representational image. In the chapter "Being Separate and Being Together," Fields decides after many failed attempts at mastering one-point perspective to try drawing an imaginary scene, and this leads to the discovery that *perspective* can also be understood in phenomenological terms. She begins to think of what objects look like from above--the shape of a table—and how they function in relation to the body--the support of a chair.

A drawing therefore is not just an accurate or crude approximation of the real thing. It is a symbolic and concrete tool that helps to mitigate (if not resist) the existential problem of "being a separate body in a world of other bodies which occupy different bits of space." (12) In turn, the aesthetic notion of "composition"--the alignment of elements on a page or in a musical score--becomes a metaphor for the healthy and necessary interrelationship to people and things. In semiotic terms, then, the drawn line--which carries a psychic charge between shapes and divisions in space--becomes equivalent to the fishing line, which, connecting one living thing to another, represents the integration of abstract form and kinetic experience.

IDEA **5. PICTURES STAND BETWEEN**, also looks to the problem of separation and connection. "Standing between" refers to the picture's ability to provide access to information, whether focusing attention or bridging various gaps between perceptions and interpretations.

In contrast, PICTURES ATTRACT AND REPEL proposes that resistance and ambivalence are built in to the promise of connection. There is sometimes tension and static on the line: the exit in the Pictou map diagram is an unknown (a black hole) as well as a possible respite from the road. The power vested in the magnet icon limits the reader's control. Milner's sketch of the room compels a view from above. The ice fisherman (experiencing better days in PICTURES STAND BETWEEN) here represents an impotence and despair that might not engage the viewer's empathy. While there is a tentative sign of hope on the Peck Driving School matchbook cover, there is also uncertainty, as the student and teacher lack legs or a suitable car.

Finally, though, the patient in the hospital bed below seems to be in the greatest difficulty. He has a lot of professional help but does not seem comforted by it. The gesture of the doctor on the left indicates doubt, even panic. The middle doctor's stance and clenched fist suggests intensity, but also seems threatening. While the third attendant appears cautiously neutral, in general the thick lines of the drawing promise neither agility on the part of the medical team, nor any release from the weight of impending crisis. "A separate body in a world of other bodies which occupy different bits of space."

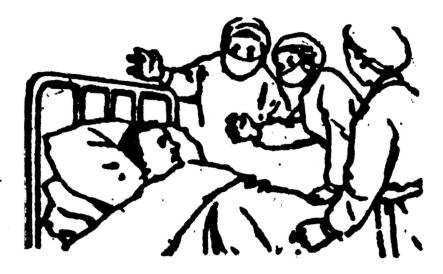

13. PICTURES GIVE DIRECTION

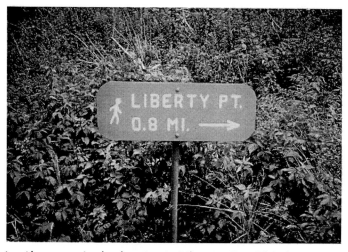

The arrow pictured in this snapshot provides a few valuable, programmatic services up front. First, as an element etched into the wooden sign, it points out the direction of a hike in the Campobello Island Provincial Park in New Brunswick, Canada. Second, by indicating the distance to the end of the trail, it establishes the boundary for what is an achievable physical goal for many people--an 0.8-mile walk to the scenic lookout at Liberty Pt. Third, it operates as a two-part visual joke. Choosing to take a photo of the sign from in close, against a background of dense, mixed foliage, makes the scale of landscape and sign somewhat ambiguous. What is the extent of this section of forest? Where are the familiar civilizing props bench, fence, fountain, hiker, backpack, car that help to mark human scale?

Taking this kind of picture during one summer vacation was a conceit on my part, but it is certainly not without precedent as a photographic convention. It was typical of landscape photography produced during nineteenth-century surveys of "uncharted" territory, as well as in archeological photos of artifacts and sites, to place some common object or measuring device within the scene to indicate size and relative scale. The presence of the walking figure on the Liberty Pt. sign adds another fillip to the illusion. The little man following the arrow from left to right is in the process of covering the 0.8 mile distance on the viewer's behalf. Modestly helping to keep the focus, and perhaps provide encouragement, is a 1950s gas station attendant who shares a cap with the Peck Driving instructor.

The character on the left is a displaced inhabitant from another graphic universe—a 1949 French book about hiking and camping. If the photo above operates like a discrete window cut into the page, the hiking man is given access to the whole space. Like Doris walking on an earlier page, his intentions can't be known, but for now he is a designated actor walking an unspecified distance across foreign terrain. Please keep off the text.

In a follow-up lesson in the *Pedagogical Sketchbook,* Paul Klee takes his "active line" and breaks its wandering path into fixed points. Like an unfolding yardstick, the line can now be used to measure more than one direction or dimension.

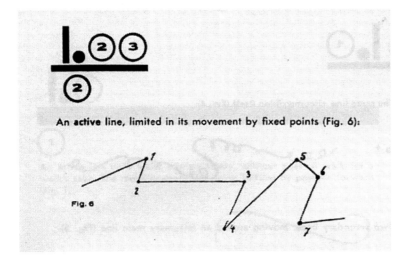

An **active** line, limited in its movement by fixed points (Fig. 6):

Fig. 6

If a line is a point plotting its position in time, then bringing in "**fixed points**" has two effects: 1) we are looking at an alternating sequence of movement and rest performed by one or more points, like a schematic diagram of dance steps; or 2) we are witnessing a **relay** in which each of seven individual points covers a limited distance and then passes on the motion or goal to the next point, as in the shipment of goods over a long haul.

While Klee calls this line **active** as he did with the freely moving gestural line, the line with "fixed points" can be read as a record of past events viewed from above. This is amplified by the inclusion of a sequence of numbers that provide a second (or third) set of points, raising the question of whether these **fixed points** themselves are active, at rest, or just another set of obstacles along the path.

Finally, if this diagram were defined as a graph, it would suggest degrees of quality (higher or lower, more or less), but since we are not given a time frame or set of limits, there is no way to be certain that what is pictured is the end of something, or a fragment of a larger evolving pattern.

This illustration is from the 1996 California Driver handbook. Like the Liberty Pt. sign it assumes that the reader understands that what it presents is not accurate, that proportionally there is not 300 feet of space between the abstract silhouettes of truck, car, and trailer. Therefore, the picture could be read as an example of what not to do unless you are driving "in a business or residence district." Either way, readers are asked to use their good judgment in both interpreting the picture and measuring their own position relative to large trucks out on the road. The trajectory of the truck is the active line and the car and trailer the limiting fixed point in cautious pursuit.

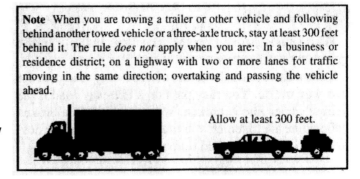

Note When you are towing a trailer or other vehicle and following behind another towed vehicle or a three-axle truck, stay at least 300 feet behind it. The rule *does not* apply when you are: In a business or residence district; on a highway with two or more lanes for traffic moving in the same direction; overtaking and passing the vehicle ahead.

Allow at least 300 feet.

14. PICTURES ELIMINATE DOUBT

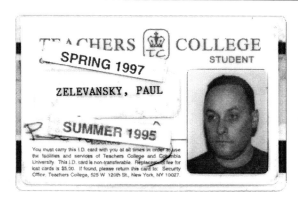

Awareness of the transforming power of the photo is often embodied in popular stories like the one about the admiring friend who said: "My that's a fine child you have there!" Mother: "Oh, that's nothing, you should see his photograph."

(McLuhan, *Understanding Media*, 188)

In the above quote, the apocryphal mother's belief in the photograph's validation of her child's good looks is not credible evidence apart from her characterization of it. The admiring friend will have to make up her own mind. In contrast, the ubiquity of the photo ID in contemporary life is tied to the need for visible proof. On one hand, the card serves as a credential alternatively generic and specific that opens doors to varieties of economic and social status. On the other hand, it is a form of protection for the party advancing credit, and for the bearer whose face appears on the card. The photo portrait is the fulcrum on which this transfer of obligation and authority depend. While standing before a security guard, I may also be relying on my haircut and the cut and condition of my clothing to certify my reliability, but the ID card is in theory designed to mitigate such subjective decision-making. Therefore, everything that I am or believe myself to be can be reduced to my possession of an official document meant to set me apart from those who do not have it. Like the keys at a mental institution that enable a guard to feel distinct from the inmates of the asylum, the photo ID is a lifeline to the Normal.

The answer to the question "What do Susan and Tommy see at the circus?" will be revealed to Susan, Tommy, and the reader when the job is done. Connecting the dots out of numerical order-- diverging from the instructional path--will result in everyone seeing _____ at the circus, but it may not be recognizable, and will certainly not result in the correct answer intended by the puzzle's designer.

In contrast to Klee's diagram of lines and fixed points, by drawing a line between this and that number or location, the puzzler controls his own destiny. When the pencil comes to rest at the final dot, the image always present but now revealed justifies the expectation endorsed by

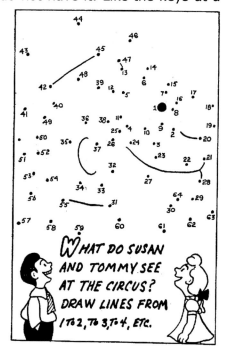

the puzzler, that there is some visible reward at the end. The promise of a comprehensible pattern linking dispersed points of reference is of course not always fulfilled by the desire to see one. But beyond the modest challenge of connecting the dots to find the right answer is the underlying belief confirmed time and time again by faith in maps that there is a concrete point in time to which a path, an action, or a wish will ultimately lead.

GEORGE SHUBA
outfielder BROOKLYN DODGERS

By establishing an iconography of athletic prowess suggesting success, strength, commitment, and affability, the sports trading card builds an association between professional athletes and ardent fans. It sets the athlete apart from the spectator, at the same time as it suggests the athlete's accessibility as a professional devoted both to the game and to the admiration and aspirations of his audience. Sports trading cards are not fragile like images on a page, or inaccessible and enshrined like those that can be hung on a wall. Their cardboard backing gives them weight, stability, endurance, and flexibility. Each card portrays a youthful face, and an active, healthy body that doesn't age or change: a heroic ideal touched with immortality.

In this 1953 Topps Chewing Gum card, George Shuba looks off into the distance, smiling, presumably happy to be representing his team and playing the game he loves. Sunlight falls on his face, but the brim of his blue cap shields his eyes. The Dodgers logo--red diamond, distinctive script, ball in flight--anchors the portrait to the foreground and establishes Shuba's connection to the Team. The green grass of the outfield glows, as the crowd, numerous but only sketched in as a blur, fills the stands behind him. Shuba, a picture of optimism and ease, is an outfielder, and this is his domain. Reading the short bio on the reverse side of the card, you learn that he has put in some years, and hard work, to reach this plateau--starting in the Dodger farm system (minor leagues) in 1944, 1952 was the first of seven seasons on the team--but the portrait only discloses the pleasure of the climb.

58

PREPARE NOW FOR THIS EVENT

The "Prepare Now for This Event" pamphlet prophecies a vision of Armageddon, when good and evil will be radically sorted out, and the messianic Jesus will return to offer the saved "fullness of joy and pleasures forever more." The thunderbolt-cum-arrow serves as a cosmic attention-getting device that theoretically points in more than one direction to more than one cosmic domain. Its graphic rhetoric has a double edge. First, it announces the urgency and inevitability of coming events and the need to prepare for the process of repentance and deliverance. Second, it visualizes the destructive and purifying force that will exact judgment on those who fail to heed the call:

This astounding event is coming swiftly and surely... perhaps much sooner than you expect. It is an event which many thousands are eagerly anticipating, but it is also an event that is a matter of great dread to other thousands.

The arrow is ultimately aimed at you—in the eternal NOW or whenever you read the pamphlet. Follow its light, heed its fire, and your salvation will be assured.

10, 9, 8, 7, 6, 5, 4, 3, 2, 1...BLAST OFF.

15. PICTURES MASK DOUBT

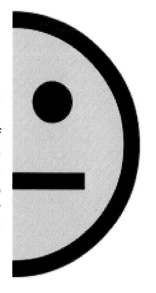

Participants in cyberspace are said to be electronically and metaphorically *on-line*. They are apart in the electronic dark, but also collaborators in some indeterminate web of exchange. This ideal of connection provides a way to imagine concrete links between virtual messages and bodies, yet in cyberspace or at a crowded party there is still the need to reckon with the tangible and intangible, to measure familiar signs of location and direction against the hazards and seductions of the unknown. Prepare now for this event.

The graphic collage conventions utilized in a typical screen design--icons, buttons, word and image links, menus, floating boxes, scrolling fields--may simulate a coherent plane of navigable details, but reading them as stable and transparent requires a suspension of disbelief as well as familiarity with the rituals and forms of the codex book. What you see and manipulate is light on a screen. A mouse click brings these narrative tools into play and another click can as easily make them disappear. The program can crash, the file be corrupted, the power fail. It is left to the skittish screen cursor, surrogate for the finger and the hand, to glide across the surface and hold the sense of connection.

In life, people take things in hand: they plant a seed, turn over a new leaf, start a new chapter, stir the pot, play the game, and, in the end, close the book.

Pictures like books shows signs of their use. Their fate is to wear out and die like living things-- paper creased, yellowed, torn, book covers and binding cracked and abraded--yet they remain tangible and concrete. The pushpin without hesitation or illusion nails documents to the wall; the staple holds them in a stack; the book, with its glued spine, weight, and heft, lends support, if not stature, to itself and the other books on the shelf. But while digital forms tethered to their codes and technology can become obsolete or lost, they do not age, but circulate, merge, and disappear into memory, or into the desktop trash—a purgatory we routinely and painlessly clear out.

Where does the screen's display arrive from and where does it go? Booting up there is the slow, stepped rise to consciousness. Shutting down, the lights go out initiating a temporary death. Held together by a vision of multivalent connection, a relentless feed to and from a collective source, the computer on-line is no less insistent in its need for attention for being virtual and immanent. Still, both digital and print images deny their fragility and transience by continuing to serve representation: the picture plays grave marker to the digital fragment's flickering ghost.

The SEE AND DRAW COPIER is a post WWII Japanese toy that uses a light source, mirror, and prism to project a scene onto a sheet of paper so that it can be traced. In order to produce a portrait of the woman, the drawing man has to look away from his subject, but he will end up with a copy on which he can reflect in the future.

What are you looking at? This ostrich appeared on a bookmark distributed by the Nature Conservancy in a 1995 fundraising mailer. A bird known popularly to stick its head in the sand to avoid danger is here emblematic of a kind of ignorance to be found in the ethical or psychological darkness. The ad plays off this notion of animal timidity and shortsightedness by giving the ostrich a new focus as a beast that may habitually avoid what it fears, but can still look back at its human critics with a jaundiced eye. After all, if we have resisted sending a donation to support the crucial, timely work of the Conservancy to preserve biological diversity, we are no better than the ostrich with its head in the sand.

The ostrich's conscription into self-parody (he embraces his doubt) allows the reader to identify with the joke and the cause which it supports, but it is people who most skillfully place their choices into categories of self-justification and need.

Upending expectations, the drink has spilled but the damage appears to be contained.

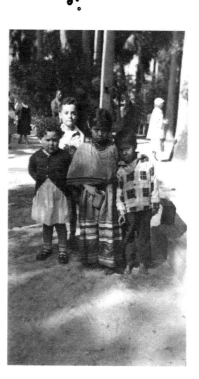

This photo was taken by my father in 1954 at the Seminole Indian reservation in south Florida. My early memory of this picture was focused on the affect and features of my sister and myself; I had not registered the taut expression of anger on the Indian girl's face, the presence of her tin begging cup, or both children's bare feet. My father genuinely loved and doted on small children and could not have imagined he was coercing them in any way. Despite his apparent willingness to look his subjects in the eye, he may only have been recording his affection for his own family, or trying to express some universal connection between children. But whatever attention or reward we were contributing towards the Indian children's temporary inclusion in our tourist family could not have been all welcome or benign. That said, it is possible to acknowledge the denser social "truth" of the moment and still appreciate that, despite my retrospective assumptions about its idealizations and omissions, the picture's contradictions deepen its effect.

Doubt is a beautiful twilight that enhances every object.

16. PICTURES ARE LIKE AN OVERHEARD CONVERSATION

To find a conversation intelligible is not the same as to understand it; for a conversation which I overhear may be intelligible, but I may fail to understand it.

<div align="right">(MacIntyre. After Virtue, 211)</div>

In *The Visitation*, painted by Mariotto Albertinelli (1474-1515), the Virgin Mary, already pregnant with Jesus, visits her older cousin Elizabeth. As central characters in a generative story, Mary and Elizabeth's private exchange signals public, symbolic meaning. Elizabeth has been told by the Archangel Gabriel that she will bear John the Baptist, and she also knows the true import of Jesus' birth: "And whence is this to me, that the Mother of the Lord should come to me?" (Luke 1:43) The setting under an arch, and what Mary and Elizabeth seem to acknowledge in each other's eyes, fulfills the requirements of the theological and art-historical frames. Yet, the emotive power of this image is not limited by those contexts. The gestures of comfort and womanly solidarity charge the moment of encounter with intimacy and a tangible warmth. Elizabeth and Mary both carry a momentous secret, and in that their fates are intertwined.

Regarded as a species of poetry, drama is therefore the formation of the word as something that moves between beings, the mystery of word and answer. Essential to it is the fact of the tension between word and answer--the fact, namely, that two men never mean the same things by the words that they use, that there is, therefore, no pure reply, that at each point of the conversation, understanding and misunderstanding are interwoven-- from which comes then the interplay of opennness and closedness, expression and reserve. (Buber, 83)

Generic icons like DINGBATS and EMOTICONS are both pragmatic and sensory, serene and sentimental. They do not fear to state the obvious. Like the Albertinelli painting, they engage in a form of emblematic speech by synthesizing a confluence of visual and verbal ideas. But while the emoticon exploits the limits of the shorthand e-mail exchange, and the dingbat is grounded in the search for a universal graphic language, their speech—overheard or employed—is easy to understand. Neither has any secrets to keep.

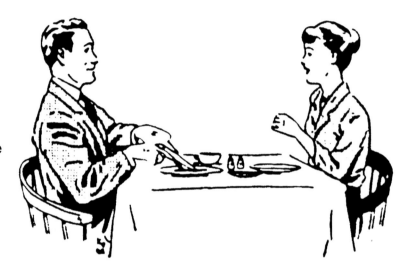

Because they mark an encounter between an appeal and a response, pictures are always in a state of anticipation. This is the second time the reader has been asked to observe this scene. Has anything changed? From this reverse angle the man seems to be leaning in more aggressively, yet he remains silent still listening to, or just tolerating, whatever the woman is saying. Echoes of cultural repression remain present in the embedded stereotype of middle-class propriety. The build up of tension, or the lack of reception, remains present in the white space between and above them giving *voice* to what is let unsaid. The couple's gestures sketch a conversation that began before this suspended moment and will continue after it.

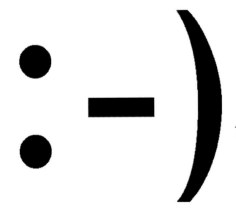

The heart of the ink painting is in space, abbreviation, what is left undrawn. In the words of the Chinese painter Chin Nung: You paint the branch well, and you hear the sound of the wind.
(Yasunari Kawabata, *Japan, The Beautiful and Myself*, 54)

66

17. PICTURES ARE BLANK SLATES

The billboard man stands proudly and confidently with his paste broom, anticipating the call to service. While it is possible that this is the first time he has confronted this particular billboard, it is as likely that the man has peeled or pasted over many previous messages and is ready to attach a new one. Any message that fills the blank could move his grin in a more specific critical direction toward reaction or commentary, but until that happens he stands guard over the available space. While the overhead lights imply a visible life for the message after dark, it is the stance of the man that gives the scene some stability and presence in time. Tall in relation to the usual billboard scale, the man can reach the top of the board with his broom without climbing a ladder or scaffold. His body is squat with a proportionally large head and the billboard itself sits firmly on the ground on five solid supports—seven if you include the man's legs and broom handle on the left side of the structure. Anywhere you locate this picture it will speak of possibility.

In *The Transfiguration of the Commonplace*, Arthur Danto proposes a fictional exhibition of identically scaled and painted red rectangles, based on a picture of the Israelites crossing the Red Sea after "The Israelites had already crossed over, and the Egyptians were drowned." Danto describes a series of artworks inspired by the first rectangle, including "Red Square, a clever bit of Moscow landscape" and "Red Table Cloth, a still life executed by an embittered student of Matisse." He then poses questions about what separates one picture from the other, what distinguishes them as aesthetic objects from commonplace things, and what makes each a work of art. In the end, since their size, color, and material are identical, it is their titles, art historical references, and the techniques employed to make them that wraps each red rectangle in the narrative of evaluation called Art.

Blank is a word, a quality, a description whose meanings are completely reliant on comparison, circumstance, and context. Something is blank in relationship to what it is not, has not, or should be; what appears to be missing or is expected to be filled in. Blankness can refer to invisibility, absence, nothingness, ideal, lack, denial, opacity, potential, stupidity, mystery, renewal. There is the BLANK as it exists in space and time: the blank page available for language, representation, mapping, and erasure; the blank or gap in comprehension and memory that may be filled by document or imagination; the indifferent, empty mirror that is filled by the world's reflections, and then judged as revelatory, indifferent, fragmented; the ~~blank~~ denial of blacked-out genitals in some pornography, or secret details and codes in top-secret reports; the blank bullet that is all noise and threat, but causes no damage; the blank space in the crossword puzzle that defines the length of names and words, and delimits a forbidden zone.

Then there is the blank slate: a tactile, pedagogical tabula rasa for the clearing of the psychological or behavioral debris; a transitional link between a past that needs forgetting or revising and a future yet to be written. The blank slate is a stage for new action: a positive step taken, a move in the right direction. The blank check, for its part, awaits an assigned value: a loan of confidence, affection, a rhetorical show of unconditional support, or, if transformed into cash with an amount and a

signature, a blanket endorsement that the bank must stand behind; the blanket indictment that covers all the legal bases; a blanket of snow that whites out the landscape and muffles sound. And then, there is the blank tile in the word game of Scrabble--any letter from A to Z--or the uniform backs of playing cards in a deck that hide the value and role of individual cards when face down.

The meaning of the black box as mechanistic model (i.e., the computer monitor or the generic light switch whose workings are concealed) is inverted with the black box as a cockpit voice or flight data recorder sought after airplane crashes and train wrecks. These black boxes retrieve and represent the facts of their functions, both memorializing the final moments of a crash and providing evidence of human or mechanical error and failure. This black box offers the possibility and comfort that seemingly inexplicable loss has causes--if not lessons for the deferral of future tragedy. The black box as simplifying mask gives way to the black box as repository of knowledge.

The billboard man inserted at the beginning and the professor from the previous page are drawn from a book of clip art called "Humorous Mortised Cuts" (Dover Books, 1986), in which each example is designed with a blank space for a message, headline, or bit of information. The specifics of a message aside, mortise cuts promise availability. "Mortise" is a printing term referring to "a space cut out of a plate, esp. for the insertion of type or another plate." The choice to use a term connected to a largely obsolete technology elides the fact that this form of clip art is made for cutting and pasting, yet it gives the idea of blankness a material resonance particularly when you compare it to the editing tools of a word processing program where CUT and PASTE (absence and presence) are essentially two transient states within a constantly shifting virtual field.

Fighting off oblivion, the BLANK seeks opportunities, searches for its target, longs for resolution, plays for time, gestures towards hallucination and reverie, feeds desire and despair. The BLANK needs to be filled in. BLANK YOU.

18. PICTURES ARE ASLEEP UNTIL THEY ARE AWAKE

Pictures are like doors left ajar half open and half closed or nightmares that linger after we awake—a mix of fact and illusion. As with dreams, they establish a psychic frame that is ultimately filled by the audience's investment in inference and implication. Calling the viewer to account, they advance and retreat with aggression or reticence. Foolish or profound, they haunt the page and leave traces in memory.

Season's Greetings

from Our House

to Your House

Did you ever lose a wallet or have it stolen, and wonder about the fate of the family snapshots inside, how they would be treated and viewed by the finder or thief who shares none of your associations, and yet is now in intimate possession of your images? What is it that you might actually repossess, if you got them back: Your property? Your privacy? The security of your family? But then you probably already have other pictures of them, so why not transfer this affection to new images? One answer is that to the degree such pictures call up feelings about those we love, they stand in for their presence outside in the world, no less than totems or voodoo dolls. Carried close in wallets and handbags and now cellphones, with other necessary personal things, snapshots must be exposed

*selectively. For them to fall into the hands of people who have violated our
private selves is to place them at risk. Their vulnerability as representations
reflects the more frightening reality of the vulnerability of the people we feel to
be in our emotional and physical care. If they came back crumpled or stained
would we still want them?*

Theft challenges the belief in the ability to
anticipate and control those aspects of life that are
most fragile. Theft punctures and destroys such
illusions of immortality and security that the life of
the copy can provide. If the picture can both
initiate and threaten contact and loss, then it is
much more than an IOU for reality.

—FIG. 22 PRECORDIAL (CHEST) THUMP—

**There is nothing abstract about the need to respond to a person in cardiac
arrest, or about the reader's being able to identify the sensation of a fist
thumping a chest. In this illustration taken from a 1974 Red Cross manual,
the recognition of the urgency and stress under which this maneuver
would be attempted only adds to its visceral impact. The picture is painfully
blunt in its presentation of concrete fact. Concentration, technique, and
discipline guide the performance of the procedure described, but the depth
of reckoning the image calls forth is sensed at the viewer's point of contact
with the scene: the fist and the arrow. Laced with sympathetic pain, this
link marks the crossing between the viewer's fear and the victim's plight.**

19. PICTURES SAVE TIME AND MONEY

"Everyone strives to reach the Law," says the man, "so how does it happen that for all these many years no one but myself has ever begged for admittance?" The doorkeeper recognizes that the man has reached his end, and, to let his failing senses catch his words, roars in his ear: "No one else could ever be admitted here, since this gate was made only for you. I am now going to shut it." (Kafka, "Before the Law," 3-4)

There is no programmatic need to decorate a credit card beyond including a logo to identify it with a specific bank or credit system, in which case the denial of counterfeiting is a primary motivation. The Wells Fargo image of a stagecoach pulled by six horses kicking up the dust and gravel of a Western landscape points to a past institutional history used to promote a current set of values. A banking corporation that has been delivering the financial goods across the U.S. since 1852, Wells Fargo is still apparently racing to save time and money. Even though the image on the ATM card is a photo made to resemble an oil painting, and the "express" cancellation stamp looks completely false, it's a successful design that manages to make the delivery of money look heroic. The romantic movie image of the Old West is the candle that lights up the scene, as rugged individualism rides the range, and the inherent conservatism of international banking holds the reins off-screen.

While the credit card places the customer figuratively at the threshold of the vault like Kafka's man before the Law, it is the invisible power of the personal identification number that provides access.

Board games are both a model and an extension of social life. *Monopoly*--a short tutorial in capital accumulation--is built around a cityscape made up of real estate subdivisions, financial opportunities and obstacles. Graphic signs (arrows, icons, cartoon figures) and text captions ("Collect $200.00," "Free Parking." "Go to Jail")

define the navigation of the board and the boundaries of success and failure, penalty and reward. The little robber baron character pictured on "Chance" and "Community Chest" cards acts as both messenger and surrogate recipient of the good and bad luck that affects strategy and bank balance.

The Treasure Hunt

Do you think the man will find the treasure with so many roads blocked? There is one way by which he can get through to the treasure! Trace this route for him on this picture-map, but remember that your pencil must not cross any lines on the way.

> Promoting a workplace where honest people feel free to challenge ideas and practices is one of the best ways we know to achieve our goal of strong, sustainable, profitable growth while preserving the highest ethical standards. (Pepsico 2003 corporate report)

The Treasure Hunt maze was taken from the same pamphlet of paper-and-pencil games as the Dickie and Doris maze. I found it in Mythology, a shop in New York City in the early 1990s which specialized in send-ups, or reclamations, of eccentric nostalgic novelties, books, toys, and games. Mythology was a kind of postmodern general store for literate consumers of pop culture history. It was never completely clear whether the past was being mimed, critiqued, exploited, or redeemed, nor could you always be certain whether you were buying a copy or an original design. Either way, what was past was not meant to be forgotten. While this "picture-map" is keyed to greed, not relationship, and the man on the hunt is armed with a rifle, trial and error remain the basic approach. The maze marks a path, but is nothing without its conceptual limits and the threat of failure. In the upbeat world of corporate reports and human potential rhetoric, impasses generate solutions and new thinking, obstacles provide opportunities for intellectual and psychic conditioning, and risk becomes the fuel that powers the passion for success. If "profitable growth" can be found at the end of the day, then the road less taken never leads to a dead end, and thinking "outside the box," or "crossing lines," isn't alienating, but good for business.

74

20. PICTURES ARE SCAPEGOATS

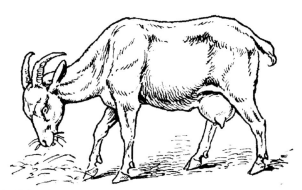

And Aaron shall lay both hands upon the head of the live goat, and confess over him all the iniquities of the children of Israel, and all their transgressions in all their sins, putting upon the head of the goat, and shall send *him* away by the hand of a fit man into the wilderness. (Leviticus 16:21)

While the sacrificial beast may appease the gods directly in the form of a tribute or public commitment--what Isaac did for Abraham, the charitable contribution does for us--the Old Testament scapegoat abandoned in the wilderness must continue to serve the ritual dispersal of sins. A sacrificial animal whether bled or consumed by fire is released from further signification by its death. In contrast, the scapegoat, marked like Cain, remains a living active reminder of moral failure and the possibility of redemption through devotion and faith.

Wedded to symbolic purpose, pictures and scapegoats
bear a common semiotic burden:

The scapegoat carries signs of transgression and failure *out* of circulation, and pictures are sometimes meant to put them back in, but subject to agendas not their own, goats and pictures are both used to set an example. Goats, conventional wisdom has it, will eat anything, and this cartoon from a 1998 Santa Fe, New Mexico newspaper suggests the same lack of discrimination in people who aspire to the appreciation of high art. Presented as a light-hearted clue to an adjacent word scramble puzzle, the cartoon relies directly on popular biases about abstract art, the self-absorbed artists who make it, and the elitist experts who evaluate it.

75

The art contest cartoon is a form of propaganda. Why would the cartoonist believe that his readers shared the same suspicions about art's value and use? Why are the artists sporting beards, long hair, and berets? Why are the judge's noses oversized and, in a stereotypical gesture of snobbery, sniffing the air for impurities and intuitions? Set up as both insiders and outsiders before a test, readers are invited to participate in a communal ritual of sanctioned behavior.

On the other hand, for those who teach art history, whether to aspiring art students or continuing education retirees, the cartoon raises useful questions about assumptions underlying abstract art, if not the whole foundation of aesthetic judgment. How to explain to those unfamiliar with the language and categories of art criticism the judge's dilemma? In what sense does it matter that one painting in the art contest differs from another? And if so, what are the distinctions and what is expected to be gained from knowing them?

Another explicit appeal to commonsense values can be found in the classic series of animated commercials aired on U.S. national television from 1962 to 1968 for Star-Kist Tuna. In these cartoons, Charlie the Tuna--a fish with the voice and fortitude of the *Honeymooner's* Ralph Cramden--aspires to upward mobility. However, his worldly ambitions are consistently questioned by both a smaller fish who acts as his comic foil and an omniscient baritone-voiced human narrator off-screen. In a typical undersea episode--"Football"--Charlie in sunglasses and beret (signifying, as in the art contest cartoon, the artistic pretensions of the easel painter, beat poet, or Hollywood director) is using a pump to inflate a football when the sensible, small fish swims by and asks how to play the game. Charlie replies in vaudevillian fashion, "You hand the ball to a friend and everyone jumps on him," and passes the little fish the ball just as a turbulent cloud of water chases him out of frame. Charlie then justifies the game and the joke with: "It's a good-taste activity. College guys do it all the time." To which the little fish replies with the knock-out punch line: **"Charlie, Star-Kist doesn't want tunas with good taste. They want tunas that taste good."** Soon after, a sign that reads "Sorry Charlie" drops from above on a fishing line as the narrator delivers a patronizing after word. Filmed testimonials from real children follow, assuring viewers of Star-Kist's good taste and desire for happy, wholesome human customers.

76

Above all else, Charlie wants to be accepted as a suitable catch by the Star-Kist Corporation, but his various efforts to achieve respectability are inevitably doomed because he resists the primary condition of employment: to "taste good" and so serve as a willing sacrifice to the good business practices of Star-Kist. Now that "fur is death" and tuna "dolphin free," consumers should be touched by his plight, but then Charlie is only an animated fish with an attitude who will live to strive and fail another day. Putting aside the bizarre conceit of Charlie's having to audition to be trapped, killed, and packed in a tin can, the little fish and the narrator make an interesting, if pragmatic, point: where sensory needs are concerned, direct participation (tasting good) is ultimately more satisfying, tangible, and trustworthy than external critical evaluation (good taste). The little fish and the narrator stand in for the savvy U.S. consumer resistant to the fishy aroma of elite, if not old-world (French) sensibilities. I may not know much, but I know what I like to eat.

But nothing lasts forever, and the deepest well runs dry...
("Where Did Everyone Go?" Nat King Cole)

In 1953, Robert Rauschenberg famously erased a Willem de Kooning drawing. Curator Walter Hopps reports that Rauschenberg (having convinced de Kooning to give him a drawing with the understanding that through erasure it would become Rauschenberg's) was interested in "exploring in a positive light the act of unmaking a work of art in contradistinction to the creation of one" (Hopps, 1991: 161). Art historian Leo Steinberg assigned an oedipal impulse to Rauschenberg's conceit as de Kooning was the older, more established artist, and apparently made sure to provide a particularly "dense example" for the task. But whether an "unmaking," backhanded homage, or act of aesthetic vandalism, the erased drawing was used to make a point; even the very recent artistic past could not withstand the purifying force of the new. On the other hand, because the drawing was not wholly destroyed, and because Rauschenberg did the deed, this emptying-out of value was ultimately replaced by a new value informed by avant-garde gesture and the floating economics of the art marketplace. Matted and set in a gold leaf frame, its hand-printed label reads "Erased de Kooning/Robert Rauschenberg/1953," suggesting a tombstone erected by a grateful, surviving heir.

Yes, nothing lasts forever, as consumption often leads to elimination. Chasing novelty, the contemporary art world routinely eats its own, and Charlie the Tuna is reduced to being a nostalgic icon on a can. But on the page, or on the screen, erasure is a graphic death that prepares the surface for rebirth: the purging of error; the clarifying of imperfect speech; the whitewashing of the pictorial or linguistic territory; the destruction of a past that is seen to need re-imagining. The icon of the block eraser within graphic programs like Photoshop visually carves a clean path through whatever material it destroys. The role of the eraser, like the scapegoat, is to edit the past and bury it out of sight. Like Paul Klee's mobilizing point and the ellipsis mark, erasure defines the direction, but not the terms, of future actions and results...

21. PICTURES ARE ABSTRACT

What do we mean when we say that something is "abstract"? Dictionary definitions explain that abstraction refers to "general ideas or terms" that are seen in various ways as "apart from concrete realities, specific objects, or actual circumstances." An abstract idea can also be seen as "impractical," "visionary and unrealistic."

In a general (abstract) sense, then, a distinction is made between *concrete*, *specific*, *actual* facts, of which Reality is composed and fictions, visions, and associations that are more elusive and so more difficult to quantify. In Art, a comparable boundary is set between recognizable images and things and non-objective forms like geometric or organic shapes.

Paradoxically, many abstract forms (stop signs, arrows) may refer to everyday practical experience, while proverbially pragmatic notions like common sense or the school of hard knocks are rhetorical abstractions. So while abstraction, in theory and practice, occupies a broad continuum of meaning--a matter of scale, classification, and degree--there is something at stake in applying its values and terms. In an implicit warning to artists and scholars, the dictionary suggests that indulging too much in abstract thinking might lead to "absent-mindedness, inattention, and mental absorption." Let us hope not.

Works of art are the product of intuition and conviction, but like the many commonplace artifacts displayed in this book, they are also reliant on a grammar of form and interpretation that extends across many life experiences and disciplines. This picture was printed on a complimentary polishing cloth collected from a hotel bathroom during a 1998 visit to Montréal. While it was clear how the cloth could be useful for cleaning

eyeglasses, why was there a razorblade? Could you safely dispose of a blade by wrapping it in the cloth? But more provocative was the juxtaposition of the eyeglasses and blade icons, side-by-side, as if two frames in a cartoon. Did their order represent a recommended sequence of possible use, a first and last act in a proscribed series, or two extremes along a spectrum of function? And then there were the instructive, metaphorical purposes to which eyeglasses and razor blade could be put: clear vision, balanced by sharp, insightful analysis; a view of the big picture, which also welcomes the slicing of the argument into its finer points. The global tempered by the local, and in the composite, the promise of intellectual hygiene all around.
AND MANY OTHER USES...

ORNAMENTAL FENCE WIRE

PAT. W.E. HATHAWAY-A.B. WOODARD, AUG. 12, 1890

This drawing of a fence functions as both exemplar and generic sample. As identified in the "Bobbed Wire" Bible by Jack Glover, it marks one design within a catalog and history of types, yet can also stand in for any wire fence. The London Tube map (below) likewise reduces complexity, in this case by providing travelers a portable means to estimate time, geography, and distance. Both represent the idea of *territory* by visualizing points of entry and circulation. While diagrams of fences and subway systems would appear to have nothing practical in common other than the abstract depiction of edges and boundaries, each is a segment of a larger system made up of intersecting links and nodes. This understanding is amplified by the fact that reduced to the scale of the page, the twists and angles of the wire visually mirror the stations and routes of the train grid.

The fence drawing and train map also share common origins as travel souvenirs: The Tube map was used during a trip to London and the *"Bobbed Wire" Bible* was purchased from a store filled with idiosyncratic cowboy lore across the plaza from the Alamo in San Antonio, Texas.

All that remains of the original Alamo building and the 1836 battle between Mexican troops and Texan and Mexican rebels is an architectural facade that fronts a small museum and gift shop. This is where I bought this souvenir postcard.

We know from everyday experience that a doorway or window marks a boundary, a potential threshold into new circumstances. The dark wooden door in the center of the Alamo photo, like the train tunnel in the Allard postcard, is a portal into and out of a story cast as history. In the theater, the proscenium frame, often aided by the rise and fall of a curtain, sets up the expectation that even the conventions of time and space may be thwarted or extended. The actors emerging from the abstract darkness break the silence, diffuse the unknown, even as the proscenium sustains the illusion of a separate reality where life as image and spectacle may be performed and shared.

This is a scanned picture of a movie ticket. It documents location, time, date, and price but offers no clue to the content of the movie beyond its title. When you use your computer and credit card to buy a ticket and then retrieve it from a cinema multiplex version of an ATM, it is the physical ticket that is checked and torn, and the stub that provides evidence of admission. While we may comfortably lose our sense of time in the dark of a movie theater, the ticket stub remains present as an anchor. It may be a forlorn fragment, but for re-entry to the theater, tax purposes, or as a piece of ephemera, it is your fragment.

2|10|07

ArcLight
Hollywood
THE LIVES OF OTHERS

Screen: 03

Row: C Seat: 27

Sat Feb 10, 2007

Time: 19:40

Adult $14.00

KIOSK: K_0A300040
T/N:551880/1

22. PICTURES NEED YOUR ATTENTION

"A bit and a bit makes a full plate." (Yiddish proverb)

Up to this point, counting duplications, there have been 128 separate pictures in the book, including clip art, diagrams, illustrations, maps, cartoons, photos, and geometric shapes. Since each is meant to make a distinct claim on the reader's attention, the strategies used are both formal and theatrical, built around composition and placement, descriptions in the text, or direct appeals through the gestures and gaze of characters. Often it is all three, as with the Pencil Guy on the left. While the dense accumulation of graphic evidence is integral to the rhetoric and rhythm of the book, the choice can cut more than one way: It may be difficult to see the theoretical forest for the many trees, and alliances with individual pictures may be fleeting. Dickie and Doris had their day in the Introduction, but where are they now? On the other hand, how and why should a few examples stand in for the complexity of all the rest? Each has been asked to perform exemplary and sometimes prophetic roles. Whether any inspire affection or allegiance is a negotiation between the picture and the reader.

The illustration on the right is from a 1965 NY State Dept. of Health pamphlet called "The Gift of Life." It is meant to explain the proportional growth of an average child, but the image is ambiguous. This appears to be a family, but in fact the two babies posed on the left and right are the "birth" versions of the figures in the middle. These taller characters (identified as three years old on the previous page in the pamphlet), look considerably older due to their hair styles.

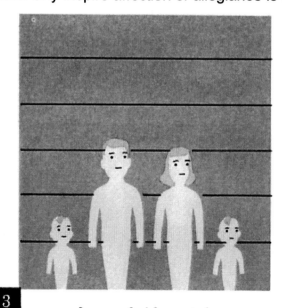

. . . boys and girls are twice as tall and four times as heavy as they were at birth.

83

Also, because they lack genitals the babies appear to be identical twins of uncertain gender. (Note the signs of maturity in the Gift of Life adolescent boy in 9. PICTURES HAVE NO EFFECTS ONLY ATTITUDES). The motif of the horizontal lines marking progressive size is consistent throughout the pamphlet and in all cases the lines overlap or cut into the bodies. This is either a production error or the effect of printing the black plate on top of the colored one. That said, once we understand that this is a pictorial chart, not a family portrait, the lines become descriptive as opposed to painful. The assorted authors of this pamphlet (heath care professionals, educators, and religious leaders) need these lessons to be sturdy, modest, and clear. An added effect brought on by the aqua blue background, the placement of bodies at the bottom of the frame, and the measuring lines above that will ultimately be reached is that optimism pervades the scene. For these figures, past and present, the future seems bright.

In this 1996 ad from the Rockwell Corporation, an artist is pictured as a young man with chiseled good looks. He wears a high-fashion version of an artist's smock and baggy trousers, an outfit more likely to be worn by a 19th-century French impressionist. (A similar costume is shared by the judges and artists in the abstraction cartoon.) Standing before an easel with an oval palette and long brushes, there is soulful concentration on the artist's face, as he seeks both the elusive muse and the admiring photographer. But what is he painting?

In any field,
imagination is a fine art.

Creativity takes many forms. And in each case, its expression is a tribute to the imaginative quest that helps define the human experience. That's why Rockwell is proud to support a wide variety of artistic endeavors.
Rockwell and its people fulfill this commitment in communities across America. Helping ensure that the fine art of imagination will continue to shape all areas of our lives.

Rockwell

Granted, the easel is turned away from us, but the perspective of the illustrator clearly celebrates the "imaginative quest" of the Rockwell artist, not his work. Yet it is fair to ask, given the opportunity to participate in this field of imagination, what subject matter might the Rockwell Artist prefer? Dappled light in a rural apple orchard or polluting smokestacks and urban industrial decay? Enhancing the pantomime of domesticated creativity, the illustrator's casual brush and ink technique signals the value of the unique handmade image and applies the patina of art to the economic and political agenda of Rockwell's high-technology business. Endangered by the modern tide of automation and mass culture, intuition, sensibility, and craft live.

84

If the other characters in this lesson are standing around waiting for their close-up, this picture from the same set of icons as the spelunker and the archer speaks of action. While there is no visible rider to clarify whether this particular climb up the rocky hill is difficult or routine, a casual ride or a competitive race, the incline of the hill and the bold graphic suggests the need for a **bold** effort. The Pencil Guy and the Rockwell Artist seem too refined for the struggle, while the Gift of Life children, apart from representing different ages in time, are not wearing any clothes. That said, unless the icon is read as a static public sign marking a trail or bike rental shop, the reader has to decide whether the bike is progressing up hill or about to roll backwards. This judgment may require a philosophical turn of mind--is the glass half empty or half full?--or just the acknowledgment that without the presence of a rider we can't know if he or she hasn't yet arrived or has already fallen off.

Returning to the accounting of collected pictures in the book, whose imagination most deserves credit for their character and presentation? Borrowed or adopted, they are my pictures now, but they still need your attention.

Please help us to have a future

23. PICTURES SEAL THEIR OWN FATE

PLATE 25. Irrelevant actions appear at low intensities.

In *The Biology of Art*, Desmond Morris documents a series of formal studies with chimps and gorillas that begins in the early years of the twentieth century and includes his own research in the 1950s. Through analyses of ape responses to guided and unguided encounters with paper and paint, a case is advanced for the biological, and therefore essential, roots of art-making and aesthetics. This includes comparisons of the resulting art work with that of young children and abstract expressionist painters. In some studies, chimps and gorillas were evaluated on how their marks corresponded to the presence of various printed geometric shapes on the paper. The qualities of splotches and lines were given less significance than their proximity to these shapes and what that might suggest about the nature of primate-artist choices.

Therefore, despite the uncertainty of aesthetic motivations, it could at least be assumed that the apes were in reaction to some stimulus on the page, including the kinetic exchange between brush, paint, and surface. While the apes were given credit for both coloring on top of and within the lines, their gestures and expressions were also characterized as motivated by intention and degrees of comprehension. In a series of eight photos of the chimp Congo painting, she is described alternatively as focused and distracted. For example:

> PLATE 23. Primitive grip, with thumb up.
> PLATE 24. Intermediate grip.
> PLATE 25. Irrelevant actions appear at low intensities.

What the researcher views as "irrelevant actions" in the above photo may, in other terms, be seen as just the kind of missing communicative link that

fuels speculation on the part of the lay viewer as to the ape's goals: do apes daydream at low intensities? How does her grip and focus compare to the Rockwell artist? While neither the researchers nor the reader have access to Congo's thinking, the caption reflects a view of lessons that can be redeemed from the picture. Empiricism joins forces with the aesthetic eye of the beholder.

In the novel *Mr. Palomar*, Italo Calvino describes the title character's doomed, yet dogged, efforts to lead his observations, social and philosophical constructs, and self-critical judgments into a coherent synthesis of perception and interpretation. Mr. Palomar, a telescope of a man struggling to look in and out at the same time, is enthused and stymied by metaphysical questions: Is there an objective set of origins and principles which inform and explain reality? Or is reality only a subjective consensus made up of individual points of view? Is Mr. Palomar himself an irrelevant if diligent presence in this world of origins and principles? Or is the world nothing more than a complex of pictures, words, sensations, and evaluations that take up residence in Mr. Palomar's head?

Mr. Palomar is structured like a set of nesting dolls: three books enclose three sections containing three stories, each of which in turn present three analytical perspectives: the visual, the anthropological, and the speculative. In "The Albino Gorilla," Mr. Palomar visits the zoo, and identifies with what he sees as the animal's profound dislocation from its surroundings. The gorilla ("Snowflake") is cut off from human and animal life outside the cage, but as a biological anomaly (a white ape) also seems alienated from fellow gorillas in his cage. During his visit, Mr. Palomar empathizes with and objectifies the gorilla's state, seeing in the animal's attachment to an automobile tire which he cradles in his arms, a reflection of his own reliance on signs and things. What the tire is for the albino gorilla, the albino gorilla is for Mr. Palomar, as both in their way seek an "escape from the dismay of living--investing oneself in things, recognizing oneself in signs, transforming the world into a collection of symbols" (83). We can speculate on Congo's attachment to his paint brush, but Mr. Palomar does not see the albino gorilla as a specimen or pet. He is a fellow captive in a world of signs that both awaits assignment and makes demands.

CATCH THE MONKEYS

The "Catch the Monkeys" game is part of the same puzzle booklet that provided the one-wing airplane.

> The object of the game is to form 4-sided boxes by connecting a line from a dot to a dot. Players take turns in making a line until a player has made a box. A player making a box puts his initial in the box and gets another turn. Score 1 point for each box made. Score 5 points if you have caught a monkey in the box.

While there is no great challenge in visualizing potential squares in a grid-like array of dots, the game does require players to look for patterns and strategize about how to arrive at a closed box. Added to this is the element of entrapment involved in getting an opponent to commit to a box that you will then complete. Perhaps most satisfying of all, though, is the opportunity to make ownership explicit and personal by getting to place your initial inside a connected box. Granted that in life, as in this lesson, there are always monkeys to catch and opponents to beat, but this group, while friendly, looks quite vulnerable before the puzzler's actions.

We are nearing the end of 24 IDEAS. The spelunker from page 1 has returned, or rather we have returned to him as he has never left the cave. There is evidence of some progress, but the spelunker's head lamp tell us that there is a distance to go in the darkness before the proverbial light at the end of the tunnel.

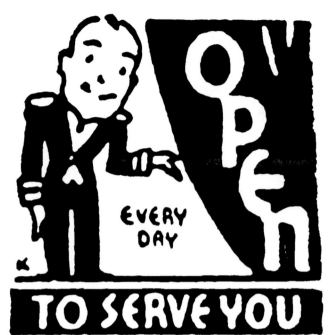

And what has happened to the clip art doorman from **5. PICTURES STAND BETWEEN**? *It is getting late. Is he any closer to his goal? Does he have a goal beyond a stoic commitment to service, to be available every day, whether he is needed or not? Looking at his face and the tilt of his body, he now seems tired. His smile strained, eyes a little sad, uniform sitting more heavily on his shoulders. Like the reader and the author, he has aged. Of course, these kinds of judgments are both hypothetical and misleading. To assign character, no less mortality, to a two-dimensional, inanimate image may be a sign of desperation on my part, but what choice do I have if I follow the implications of all the IDEAS that precede this one? Unless I want to reduce the doorman's to an abstract category or type, he is looking at me, so I have a responsibility to look back.*

> From the mute distance of things, a sign must come, a summons, a wink: one thing detaches itself from the other things with the intention of signifying something... what? Itself, a thing is happy to be looked at by other things only when it is convinced that it signifies itself and nothing else, amid things that signify themselves and nothing else. (*Mr. Palomar*, 115)

Near the close of the book in "The World Looks at the World," Mr. Palomar has a conceptual breakthrough of sorts. As he looks through his window, he realizes that the world "outside" and the one "inside" of which he is a part are reciprocal. He is relatively clear about his own skill in analyzing what is in front of him, but sees no reason to believe that the outside world doesn't have the ability, if not the need, to return the favor. This proposal offers Mr. Palomar some comfort, late in the day, promising to lessen the gap between his isolated, ego-driven perspective and the more inclusive facts of the environment that, however elusive, are certainly there. Yet not to criticize a man who has struggled throughout Calvino's book to demystify and critique his own assumptions, in the end he may be showing signs of fatigue: "a thing is happy to be looked at by other things only when it is convinced..." Must all signs be in thrall to their own sense of uniqueness? That said, I think we owe Mr. Palomar—and the doorman—our

admiration and sympathy as we are hardly in a position to stand apart from their condition. Weight and counterweight.

Finally, there is the case of the razor blade lifted from the hotel polishing cloth. Cut loose from the eyeglasses, it is now in conceptual free fall, drawn like an arrow towards some unknown target. The blade drops through space bounded by radiant lines of graphic exclamation that pulse with light and self-consciousness. **"I am here, I am falling, I have no idea why."** But positioned with white space below it, the blade's path has no clear limits (other than the page number and the paper's edge). A turn of this page and it will drop out of sight and into memory, denying the argument a final distinction. Mission control, the picture has...

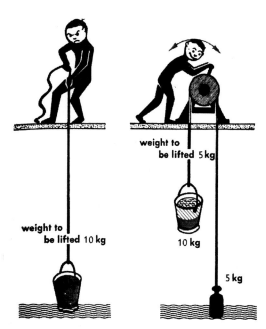

weight to be lifted 5 kg

weight to be lifted 10 kg

10 kg

5 kg

Fig. 1 PRINCIPLE OF WEIGHT AND COUNTERWEIGHT

91

24. A PICTURE IS IN FACT A FILE

The picture of the computer file that appears below encompasses both rhetorically and practically many of the analytical concerns of 24 IDEAS ABOUT PICTURES. The consolidation on the screen of the book's content as a single icon incorporating the formatted text and images of the manuscript is not only a wonder of software technology's ubiquity and dominance. It is also an emblem of the dynamic power and flexibility of the graphic sign.

While the icon reveals nothing--other than the title--of the content behind its combined Macintosh/Microsoft Word logo, the fruits of its existence and function surround it and can be known by the reader: the real-world hard copy that the reader holds in her hands is given life in the digital space of the computer monitor by the processes that the file icon represents.

With this picture of the icon, 24 IDEAS functionally begins, and now graphically ends.

24 IDEAS ABOUT PICTURES

Yet, while this statement is conceptually appealing, it is not completely true. In a few pages, the clip art image of a stack of books appears over the Bibliography. What initially (in the Introduction) stood in for all books, here represents the specific books referenced in 24 IDEAS. In addition, on the back cover, there

is a sample image and short text from 3. PICTURES LOOK YOU IN THE EYE that is meant to exemplify the content within. The "expectant, sad, confused" eyes of the Smiley Face without-a-mouth look longingly out to the reader as if to say goodbye.

Finally, there is the book's ISBN barcode which identifies 24 IDEAS as a generic product with some unique, but invisible, characteristics. A barcode is a machine-readable diagram made up of alternating lines and spaces, or patterns and images. Barcode scanners read the density and thickness of lines, and the spaces between, that record a product's identity within a local or world-wide marketplace. With the International Standard Book Number (ISBN) identification means a book's author, title, publisher, language and sources of distribution.

The barcode pictured here does not belong to 24 IDEAS but was reproduced from the back cover of D.W. Winnicott's *Playing & Reality*. As much as I value any association with the Winnicott book, its barcode is not a quotation, just a picture of a barcode. But is a barcode a picture? Unlike a portrait or landscape, you can't equate what it looks like to what it represents. The information a barcode scanner reveals describes a book in very schematic ways, like a citizen in a census. But if you apply Nelson Goodman's formulation of "entities and kinds," the barcode does portray a picture of reality in certain objective and unsentimental terms. While the Microsoft Word file reflects the author's conception and labor, the ISBN barcode makes it clear that once the manuscript becomes a book, it is on its own.
Best of luck.

BIBLIOGRAPHY

Arendt, Hannah. *The Human Condition*. New York: Anchor Books, 1959.

Benjamin, Walter. "Theses on a Philosophy of History," *Illuminations*, Trans. Harry Zohn. New York: Schocken Books, 1969.

Calvino, Italo. *Mr. Palomar*. trans. William Weaver. Harcourt Brace Jovanovich, 1985.

Danto, Arthur. *The Transfiguration of the Commonplace*. Cambridge: Harvard UP, 1981

Field, Johanna. *On Not Being Able to Paint*. Los Angeles: Jeremy Tarcher, Inc. 1964.

Goodman, Nelson. *Ways of Worldmaking*: Indianapolis, IN: Hackett Publishing, 1978.

Hopps, Walter. *Robert Rauschenberg: The Early 1950s*. Houston: Houston Fine Arts Press. 1991.

Hull, John M. *Touching the Rock* . New York: Pantheon Books, 1990.

Kafka, Franz. "Before the Law." Trans. Willa and Edwin Muir. *The Complete Stories*. Ed. Nahum Glatzer. New York: Schocken Books,1976.

Kawabata, Yasunari. *Japan, the Beautiful and Myself*. Trans. E.G. Seidensticker. Tokyo: Kodansha International, 1969.

Klee, Paul. *Pedagogical Sketchbook*. Introduction and trans. Sibyl Moholy-Nagy New York: Praeger, 1953.

MacIntyre, Alasdair, *After Virtue*. South Bend, IN: Notre Dame UP, 1984.

McCloud, Scott, *Understanding Comics* . New York: Harper Perennial, 1993.

McLuhan, Marshall, *Understanding Media* . Cambridge: M.I.T. Press, 1994.

Merleau-Ponty, Maurice, *The Primacy of Perception*, Evanston, IL: Northwestern UP, 1964

Morris, Desmond, *The Biology of Art*. New York: Knopf, 1962.

Plato, *The Republic*. Trans. Francis MacDonald Cornford. New York: Oxford UP, 1945.

Stewart, Susan, *On Longing*. Durham, NC: Duke UP, 1993.

Tomkins, William, *Indian Sign Language*. New York: Dover Pub, 1969.

Wittgenstein, Ludwig. *Tractatus Logico- Philosophicus*. London: Routledge & Kegan Paul, 1961.

Winnicott, D.W. *Playing & Reality* . New York: Routledge, 1971.